PICASSO

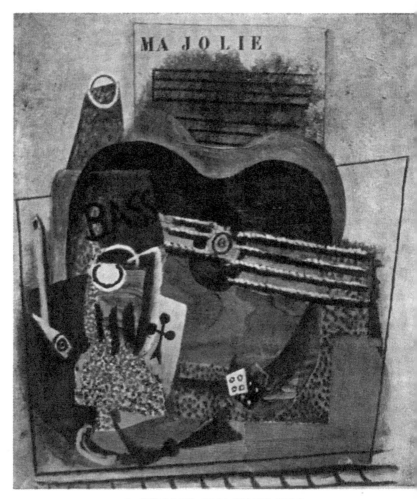

1 STILL-LIFE, "MA JOLIE" (1914)

PICASSO

By

GERTRUDE STEIN

DOVER PUBLICATIONS, INC.
New York

This Dover edition, first published in 1984, is an unabridged republication of the work originally published by B. T. Batsford Ltd, London, in 1938. Plates 1, 2, 7, 21, 22, 29, 34 and 61, originally reproduced in color, are here reproduced in black and white.

Library of Congress Cataloging in Publication Data

Stein, Gertrude, 1874-1946.
 Picasso.

 Reprint. Originally published: London : B.T. Batsford, 1938.
 Includes index.
 1. Picasso, Pablo, 1881-1973. I. Title.
ND553.P5S8 1984 759.4 84-5934
ISBN-13: 978-0-486-24715-1
ISBN-10: 0-486-24715-5

Manufactured in the United States by Courier Corporation
24715517
www.doverpublications.com

LIST OF ILLUSTRATIONS

v

Note

All the subjects illustrated are from Oil Paintings unless otherwise stated

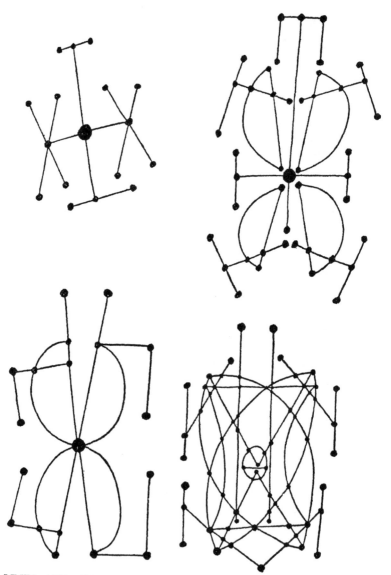

LINES AND STARS
Drawing in Pure Calligraphy (1923)

PICASSO

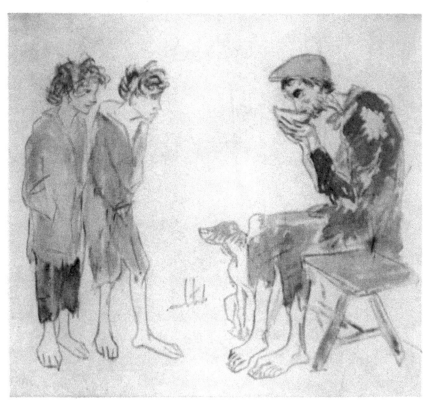

2 LES PAUVRES: *Water Colour* (1902)

PICASSO

PAINTING in the nineteenth century was only done in France and by Frenchmen, apart from that, painting did not exist, in the twentieth century it was done in France but by Spaniards.

In the nineteenth century painters discovered the need of always having a model in front of them, in the twentieth century they discovered that they must never look at a model. I remember very well, it was between 1904–1908, when people were forced by us or by themselves to look at Picasso's drawings that the first and most astonishing thing that all of them and that we had to say was that he had done it all so marvellously as if he had had a model but that he had done it without ever having had one. And now the young painters scarcely know that there are models. Everything changes but not without a reason.

When he was nineteen years old Picasso came to Paris, that was in 1900, into a world of painters who had completely learned everything they could from seeing at what they were looking. From Seurat to Courbet they were all of them looking with their eyes and Seurat's eyes then began to tremble at what his eyes were seeing, he commenced to doubt if in looking he could see. Matisse too began to

doubt what his eyes could see. So there was a world ready for Picasso who had in him not only all Spanish painting but Spanish cubism which is the daily life of Spain.

His father was professor of painting in Spain and Picasso wrote painting as other children wrote their a b c. He was born making drawings, not the drawings of a child but the drawings of a painter. His drawings were not of things seen but of things expressed, in short they were words for him and drawing always was his only way of talking and he talks a great deal.

Physically Picasso resembles his mother whose name he finally took. It is the custom in Spain to take the name of one's father and one's mother. The name of Picasso's father was Ruiz, the name of his mother was Picasso, in the Spanish way he was Pablo Picasso y Ruiz and some of his early canvases were signed Pablo Ruiz but of course Pablo Picasso was the better name, Pablo Picasso y Ruiz was too long a name to use as a signature and he commenced almost at once to sign his canvases Pablo Picasso.

The name Picasso is of Italian origin, probably originally they came from Genoa and the Picasso family went to Spain by way of Palma de Mallorca. His mother's family were silversmiths. Physically his mother like Picasso is small and robust with a vigorous body, dark-skinned, straight not very fine nearly black hair, on the other hand Picasso always used to say his father was like an Englishman of which both Picasso and his father were proud, tall and with reddish hair and with almost an English way of imposing himself.

The only children in the family were Picasso and his younger sister. He made when he was fifteen years old

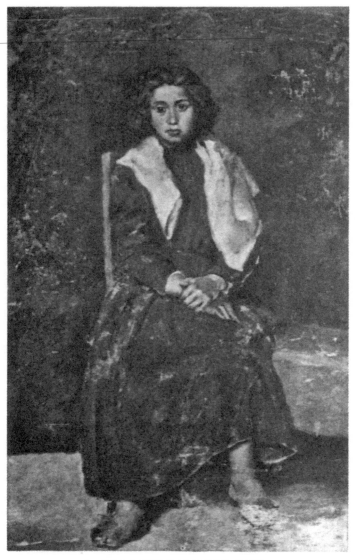

3 GIRL WITH BARE FEET (1895)

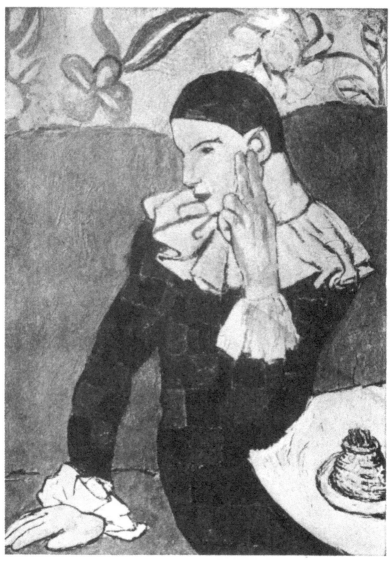

4 HARLEQUIN AND MATCHES (1901)

oil portraits of her, very finished and painted like a born painter.

Picasso was born in Malaga the 25th of October 1881 but he was educated almost entirely in Barcelona where his father until almost the end of his life was professor of painting at the academy of Fine Arts and where he lived until his death, his mother continued living there with his sister. She has just died there.

Well then, Picasso at nineteen years of age was in Paris where, except for very rare and short visits to Spain, he has lived all his life.

He was in Paris.

His friends in Paris were writers rather than painters, why have painters for friends when he could paint as he could paint.

It was obvious that he did not need to have painters in his daily life and this was true all his life.

He needed ideas, anybody does, but not ideas for painting, no, he had to know those who were interested in ideas, but as to knowing how to paint he was born knowing all of that.

So in the beginning he knew intimately Max Jacob and at once afterwards Guillaume Apolliniaire and André Salmon, and later he knew me and much later Jean Cocteau and still later the Surréalistes, this is his literary history. His intimates amongst the painters, and this was later, much later than Max Jacob and than Guillaume Apollinaire and than André Salmon and than I, were Braque and Derain, they both had their literary side and it was this literary side that was the reason for their friendship with Picasso.

3

The literary ideas of a painter are not at all the same ideas as the literary ideas of a writer. The egotism of a painter is entirely a different egotism than the egotism of a writer.

The painter does not conceive himself as existing in himself, he conceives himself as a reflection of the objects he has put into his pictures and he lives in the reflections of his pictures, a writer, a serious writer, conceives himself as existing by and in himself, he does not at all live in the reflection of his books, to write he must first of all exist in himself, but for a painter to be able to paint, the painting must first of all be done, therefore the egotism of a painter is not at all the egotism of a writer, and this is why Picasso who was a man who only expressed himself in painting had only writers as friends.

In Paris the contemporary painters had little effect upon him but all the painting he could see of the very recent past profoundly touched him.

He was always interested in painting as a metier, an incident that happened once is characteristic. In Paris there was an American sculptress who wished to show her canvases and sculpture at the salon. She had always shown her sculpture at the salon where she was *hors concours* but she did not wish to show sculpture and painting at the same salon. So she asked Miss Toklas to lend her her name for the pictures. This was done. The pictures were accepted in the name of Miss Toklas, they were in the catalogue and we had this catalogue. The evening of the *vernissage* Picasso was at my house. I showed him the catalogue, I said to him, here is Alice Toklas who has never painted and who has had a picture accepted at the salon. Picasso went red, he said, it's not possible, she has been painting in

4

secret for a long time, never I tell you, I said to him. It isn't possible, he said, not possible, the painting at the salon is bad painting, but even so if any one could paint as their first painting a picture that was accepted, well then I don't understand anything about anything. Take it easy, I said to him, no she didn't paint the picture, she only lent her name. He was still a little troubled, no, he repeated, you have to know something to paint a picture, you have to, you have to.

Well he was in Paris and all painting had an influence upon him and his literary friends were a great stimulation to him. I do not mean that by all this he was less Spanish. But certainly for a short time he was more French. Above all, and this is quite curious, the painting of Toulouse Lautrec greatly interested him, was it once more because Lautrec too had a literary side.

The thing that I want to insist upon is that Picasso's gift is completely the gift of a painter and a draughtsman, he is a man who always has need of emptying himself, of completely emptying himself, it is necessary that he should be greatly stimulated so that he could be active enough to empty himself completely.

This was always the way he lived his life.

After this first definite French influence he became once more completely Spanish. Very soon the Spanish temperament was again very real inside in him. He went back again to Spain in 1902 and the painting known as his blue period was the result of that return.

The sadness of Spain and the monotony of the Spanish coloring, after the time spent in Paris, struck him forcibly upon his return there. Because one must never forget

that Spain is not like other southern countries, it is not colorful, all the colors in Spain are white black silver or gold, there is no red or green, not at all. Spain in this sense is not at all southern, it is oriental, women there wear black more often than colors, the earth is dry and gold in color, the sky is blue almost black, the star-light nights are black too or a very dark blue and the air is very light, so that every one and everything is black. All the same I like Spain. Everything that was Spanish impressed itself upon Picasso when he returned there after his second absence and the result is what is known as his blue period. The French influence which had made his first or Toulouse Lautrec one was over and he had returned to his real character, his Spanish character.

Then again in 1904 he was once again in Paris.

He lived in Montmartre, in the rue Ravignan, its name has been changed now, but the last time I was there it still had its old charm, the little square was just as it was the first time I saw it, a carpenter was working in a corner, the children were there, the houses were all about the same as they had been, the old atelier building where all of them had lived was still standing, perhaps since then, for it is two or three years that I was there last, perhaps now they have commenced to tear it all down and build another building. It is normal to build new buildings but all the same one does not like anything to change and the rue Ravignan of that time was really something, it was the rue Ravignan and it was there that many things that were important in the history of twentieth century art happened.

Anyway Picasso had once more returned to Paris and it was around 1904 and he brought back with him the

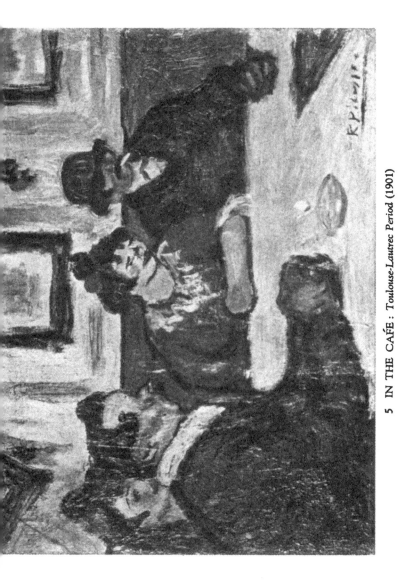

5 IN THE CAFÉ : *Toulouse-Lautrec Period* (1901)

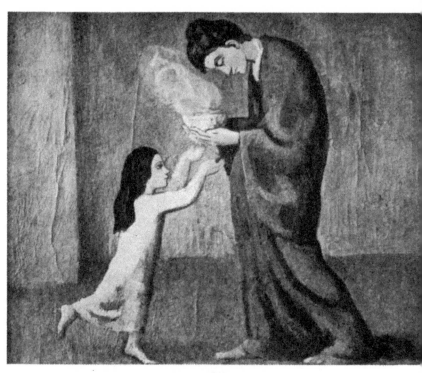

6 MOTHER AND CHILD : *Blue Period (Summer, 1902)*

pictures of the blue period, also a little landscape of this period which he had painted in Barcelona. Once more back in Paris he commenced again to be a little French, that is he was again seduced by France, there was his intimacy with Guillaume Apollinaire and Max Jacob and André Salmon and they were constantly seeing each other, and this once again relieved his Spanish solemnity and so once more, needing to completely empty himself of everything he had, he emptied himself of the blue period, of the renewal of the Spanish spirit and that over he commenced painting what is now called the rose or harlequin period.

Painters have always liked the circus, even now when the circus is replaced by the cinema and night clubs, they like to remember the clowns and acrobats of the circus.

At this time they all met at least once a week at the Cirque Medrano and there they felt very flattered because they could be intimate with the clowns, the jugglers, the horses and their riders. Picasso little by little was more and more French and this started the rose or harlequin period. Then he emptied himself of this, the gentle poetry of France and the circus, he emptied himself of them in the same way that he had emptied himself of the blue period and I first knew him at the end of this harlequin period.

The first picture we had of his is, if you like, rose or harlequin, it is The Young Girl With a Basket of Flowers, it was painted at the great moment of the harlequin period, full of grace and delicacy and charm. After that little by little his drawing hardened, his line became firmer, his color more vigorous, naturally he was no longer a boy he was a man, and then in 1905 he painted my portrait.

Why did he wish to have a model before him just at this

time, this I really do not know, but everything pushed him to it, he was completely emptied of the inspiration of the harlequin period, being Spanish commenced again to be active inside in him and I being an American, and in a kind of a way America and Spain have something in common, perhaps for all these reasons he wished me to pose for him. We met at Sagot's, the picture dealer, from whom we had bought The Girl with a Basket of Flowers. I posed for him all that winter, eighty times and in the end he painted out the head, he told me that he could not look at me any more and then he left once more for Spain. It was the first time since the blue period and immediately upon his return from Spain he painted in the head without having seen me again and he gave me the picture and I was and I still am satisfied with my portrait, for me, it is I, and it is the only reproduction of me which is always I, for me.

A funny story.

One day a rich collector came to my house and he looked at the portrait and he wanted to know how much I had paid for it. Nothing I said to him, nothing he cried out, nothing I answered, naturally he gave it to me. Some days after I told this to Picasso, he smiled, he doesn't understand, he said, that at that time the difference between a sale and a gift was negligible.

Once again Picasso in 1909 was in Spain and he brought back with him some landscapes which were, certainly were, the beginning of cubism. These three landscapes were extraordinarily realistic and all the same the beginning of cubism. Picasso had by chance taken some photographs of the village that he had painted and it always amused me when every one protested against the fantasy of the pictures

8

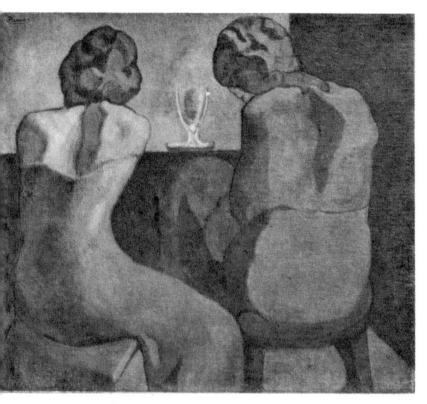

7 WOMEN AT A BAR : *Blue Period* (1902)

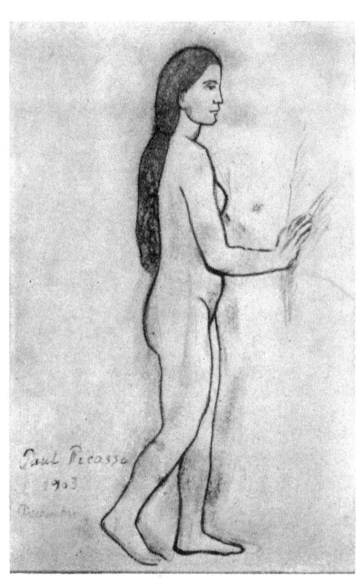

8 NUDE: *Charcoal Drawing* (1903)

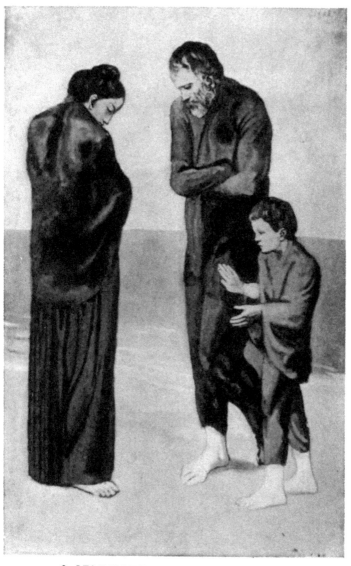

9 LES PAUVRES AU BORD DE LA MER:
Blue Period (Summer, 1903)

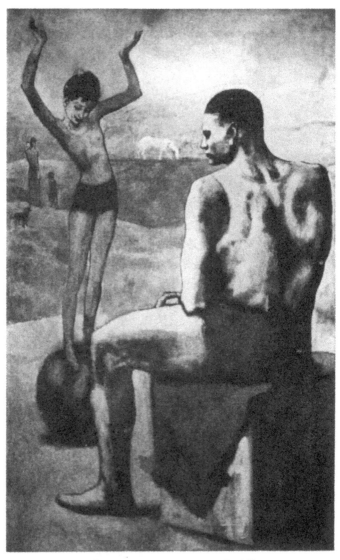

10 LA FILLETTE SUR LA BOULE :
Rose Period (Autumn, 1904)

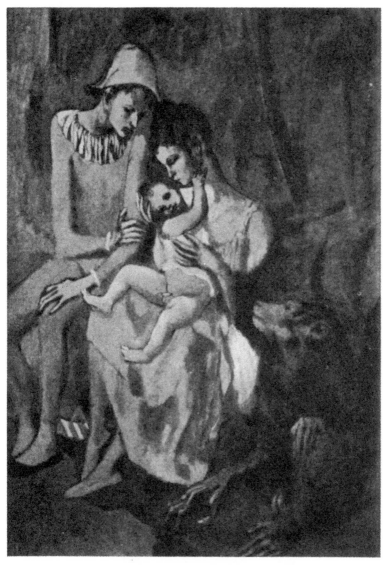

11 LA FAMILLE D'ARLEQUIN AU SINGE :
Rose Period (Spring, 1905)

to make them look at the photographs which made them see that the pictures were almost exactly like the photographs. Oscar Wilde used to say that nature did nothing but copy art and really there is some truth in this and certainly the Spanish villages were as cubistic as these paintings.

So Picasso was once more baptised Spanish.

Then commenced the long period which Max Jacob has called the Heroic Age of Cubism, and it was an heroic age. All ages are heroic, that is to say there are heroes in all ages who do things because they cannot do otherwise and neither they nor the others understand how and why these things happen. One does not ever understand, before they are completely created, what is happening and one does not at all understand what one has done until the moment when it is all done. Picasso said once that he who created a thing is forced to make it ugly. In the effort to create the intensity and the struggle to create this intensity, the result always produces a certain ugliness, those who follow can make of this thing a beautiful thing because they know what they are doing, the thing having already been invented, but the inventor because he does not know what he is going to invent inevitably the thing he makes must have its ugliness.

At this period 1908–1909, Picasso had almost never exhibited his pictures, his followers showed theirs but he did not. He said that when one went to an exhibition and looked at the pictures of the other painters one knows that they are bad, there is no excuse for it they are simply bad, but one's own pictures, one knows the reasons why they are bad and so they are not hopelessly bad. At this

9

time he liked to say and later too he used to repeat it, there are so few people who understand and later when every one admires you there are still the same few who understand, just as few as before.

So then Picasso came back from Spain, 1908, with his landscapes that were the beginning of cubism. To really create cubism he had still a long way to go but a beginning had been made.

One can say that cubism has a triple foundation. First. The nineteenth century having exhausted its need of having a model, because the truth that the things seen with the eyes are the only real things, had lost its significance.

People really do not change from one generation to another, as far back as we know history people are about the same as they were, they have had the same needs, the same desires, the same virtues and the same qualities, the same defects, indeed nothing changes from one generation to another except the things seen and the things seen make that generation, that is to say nothing changes in people from one generation to another except the way of seeing and being seen, the streets change, the way of being driven in the streets change, the buildings change, the comforts in the houses change, but the people from one generation to another do not change. The creator in the arts is like all the rest of the people living, he is sensitive to the changes in the way of living and his art is inevitably influenced by the way each generation is living, the way each generation is being educated and the way they move about, all this creates the composition of that generation.

This summer I was reading a book written by one of the monks of the Abbey of Hautecombe about one of the

abbots of Hautecombe and in it he writes of the founding of the abbey and he tells that the first site was on a height near a very frequented road. Then I asked all my French friends what was in the fifteenth century a very frequented road, did it mean that people passed once a day or once a week. More than that, they answered me. So then the composition of that epoch depended upon the way the roads were frequented, the composition of each epoch depends upon the way the frequented roads are frequented, people remain the same, the way their roads are frequented is what changes from one century to another and it is that that makes the composition that is before the eyes of every one of that generation and it is that that makes the composition that a creator creates.

I very well remember at the beginning of the war being with Picasso on the boulevard Raspail when the first camouflaged truck passed. It was at night, we had heard of camouflage but we had not yet seen it and Picasso amazed looked at it and then cried out, yes it is we who made it, that is cubism.

Really the composition of this war, 1914–1918, was not the composition of all previous wars, the composition was not a composition in which there was one man in the centre surrounded by a lot of other men but a composition that had neither a beginning nor an end, a composition of which one corner was as important as another corner, in fact the composition of cubism.

At present another composition is commencing, each generation has its composition, people do not change from one generation to another generation but the composition that surrounds them changes.

Now we have Picasso returning to Paris after the blue period of Spain, 1904, was past, after the rose period of France, 1905, was past, after the negro period, 1907, was past, with the beginning of his cubism, 1908, in his hand. The time had come.

I have said that there were three reasons for the making of this cubism.

First. The composition, because the way of living had changed the composition of living had extended and each thing was as important as any other thing. Secondly, the faith in what the eyes were seeing, that is to say the belief in the reality of science, commenced to diminish. To be sure science had discovered many things, she would continue to discover things, but the principle which was the basis of all this was completely understood, the joy of discovery was almost over.

Thirdly, the framing of life, the need that a picture exist in its frame, remain in its frame was over. A picture remaining in its frame was a thing that always had existed and now pictures commenced to want to leave their frames and this also created the necessity for cubism.

The time had come and the man. Quite naturally it was a Spaniard who had felt it and done it. The Spaniards are perhaps the only Europeans who really never have the feeling that things seen are real, that the truths of science make for progress. Spaniards did not mistrust science they only never have recognised the existence of progress. While other Europeans were still in the nineteenth century, Spain because of its lack of organisation and America by its excess of organisation were the natural founders of the twentieth century.

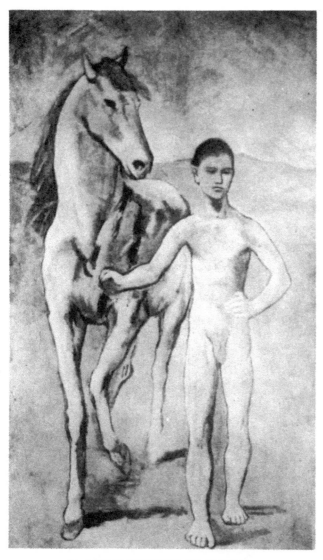

12 JEUNE GARÇON AU CHEVAL

(Winter, 1905)

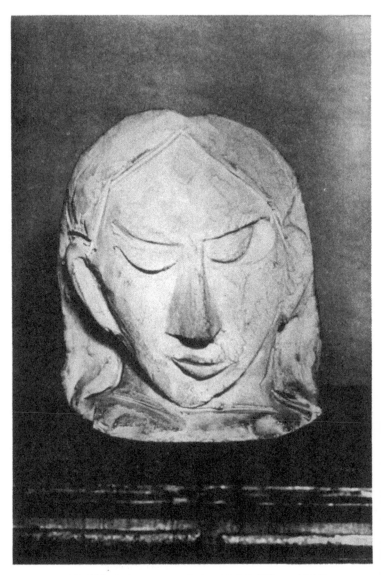

13 HEAD OF A WOMAN : *Modelled Plaster* (1906)

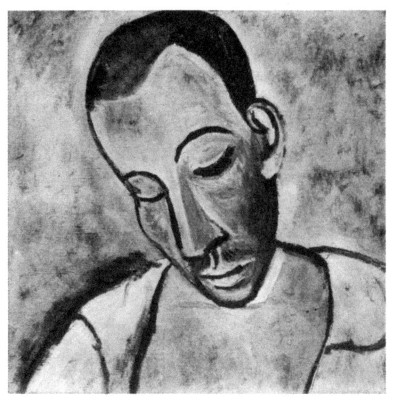

14 HEAD OF A MAN (*Spring*, 1907)

15 PORTRAIT OF GUILLAUME APOLLINAIRE
(" *Culture Physique* ") : *Ink Drawing* (1906)

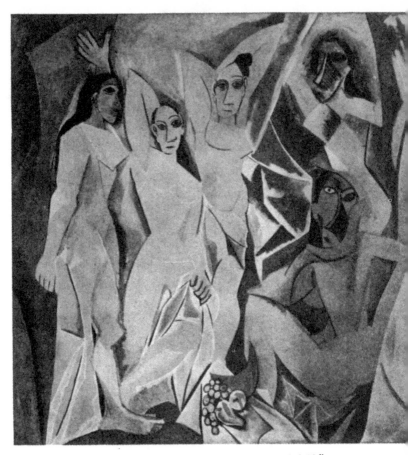

16 LES DEMOISELLES D'AVIGNON (1906)

Cubism was commencing. Returning from Spain Picasso went back to the rue Ravignan but it was almost the end of the rue Ravignan, he commenced to move from one studio to another in the same building and when cubism was really well established, that is the moment of the pictures called Ma Jolie, 1910, he had left the rue Ravignan and a short time after he left Montmartre, 1912, and he never after returned to it.

After his return from Spain with his first cubist landscapes in his hand, 1909, a long struggle commenced.

Cubism began with landscapes but inevitably he then at once tried to use the idea he had in expressing people. Picasso's first cubist pictures were landscapes, he then did still lifes but Spaniard that he is, he always knew that people were the only interesting thing to him. Landscapes and still lifes, the seduction of flowers and of landscapes, of still lifes were inevitably more seductive to Frenchmen than to Spaniards, Juan Gris always made still lifes but to him a still life was not a seduction it was a religion, but the ecstasy of things seen, only seen; never touches the Spanish soul.

The head the face the human body these are all that exist for Picasso. I remember once we were walking and we saw a learned man sitting on a bench, before the war a learned man could be sitting on a bench, and Picasso said, look at that face, it is as old as the world, all faces are as old as the world.

And so Picasso commenced his long struggle to express heads faces and bodies of men and of women in the composition which is his composition. The beginning of this struggle was hard and his struggle is still a hard struggle,

the souls of people do not interest him, that is to say for him the reality of life is in the head, the face and the body and this is for him so important, so persistent, so complete that it is not at all necessary to think of any other thing and the soul is another thing.

The struggle then had commenced.

Most people are more predetermined as to what is the human form and the human face than they are as to what are flowers, landscapes, still lifes. Not everybody. I remember one of the first exhibitions of Van Gogh, there was an American there and she said to her friend, I find these portraits of people quite interesting for I don't know what people are like but I don't at all like these flower pictures because I know very well what flowers are like.

Most people are not like that. I do not mean to say that they know people better than they know other things but they have stronger convictions about what people are than what other things are.

Picasso at this period often used to say that Spaniards cannot recognise people from their photographs. So the photographers made two photographs, a man with a beard and a man smooth shaven and when the men left home to do their military service they sent one of these two types of photographs to their family and the family always found it very resembling.

It is strange about everything, it is strange about pictures, a picture may seem extraordinarily strange to you and after some time not only it does not seem strange but it is impossible to find what there was in it that was strange.

A child sees the face of its mother, it sees it in a completely different way than other people see it, I am not speaking

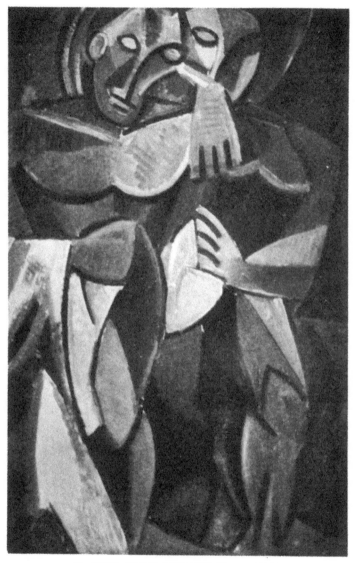

17 TWO NUDE WOMEN (*Spring*, 1908)

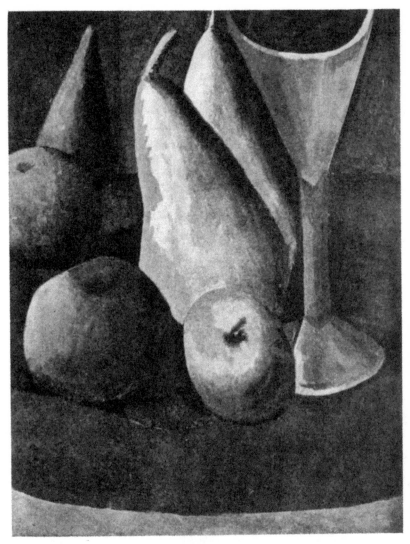

18 FRUIT AND GLASS : *Gouache* (1908)

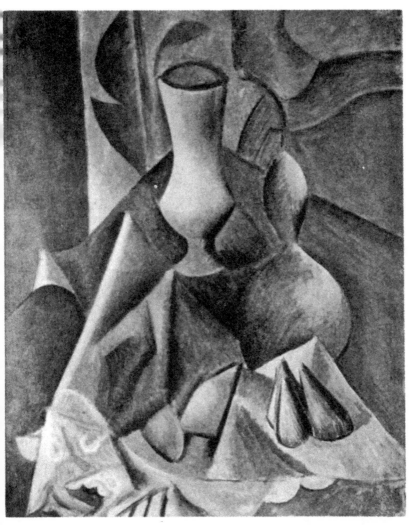

19 STILL-LIFE WITH FIGS : *Green Period* (1909)

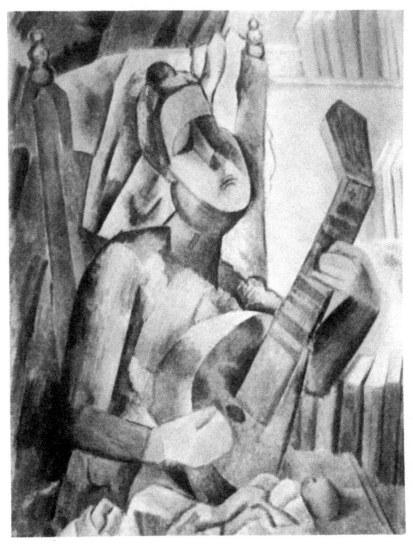

20 WOMAN WITH GUITAR (1909)

of the spirit of the mother but of the features and the whole face, the child sees it from very near, it is a large face for the eyes of a small one, it is certain the child for a little while only sees a part of the face of its mother, it knows one feature and not another, one side and not the other, and in his way Picasso knows faces as a child knows them and the head and the body. He was then commencing to try to express this consciousness and the struggle was appalling because, with the exception of some African sculpture, no one had ever tried to express things seen not as one knows them but as they are when one sees them without remembering having looked at them.

Really most of the time one sees only a feature of a person with whom one is, the other features are covered by a hat, by the light, by clothes for sport and everybody is accustomed to complete the whole entirely from their knowledge, but Picasso when he saw an eye, the other one did not exist for him and only the one he saw did exist for him and as a painter, and particularly as a Spanish painter, he was right, one sees what one sees, the rest is a reconstruction from memory and painters have nothing to do with reconstructions, nothing to do with memory, they concern themselves only with visible things and so the cubism of Picasso was an effort to make a picture of these visible things and the result was disconcerting for him and for the others, but what else could he do, a creator can only do one thing, he can only continue, that is all he can do.

The beginning of this struggle to express the things, only the really visible things, was discouraging, even for his most intimate friends, even for Guillaume Apollinaire.

At this time people had commenced to be quite interested

15

in the painting of Picasso, not an enormous number of people but even so quite a few, and then Roger Fry, an Englishman, was very impressed by my portrait and he had it reproduced in The Burlington Magazine, the portrait by Picasso next to a portrait by Raphael, and he too was very disconcerted. Picasso said to me once with a good deal of bitterness, they say I can draw better than Raphael and probably they are right, perhaps I do draw better but if I can draw as well as Raphael I have at least the right to choose my way and they should recognise it, that right, but no, they say no.

I was alone at this time in understanding him, perhaps because I was expressing the same thing in literature, perhaps because I was an American and, as I say, Spaniards and Americans have a kind of understanding of things which is the same.

Later Derain and Braque followed him and helped him but at this time the struggle remained a struggle for Picasso and not for them.

We are now still in the history of the beginning of that struggle.

Picasso commenced as I have said, at the end of the harlequin or rose period to harden his lines his construction and his painting and then he once more went to Spain, he stayed there all summer and when he came back he commenced some things which were more absolute and this led him to do the picture Les Desmoiselles d'Avignon. He left again for Spain and when he returned he brought back with him those three landscapes which were the real beginning of cubism.

It is true certainly in the water colors of Cezanne that

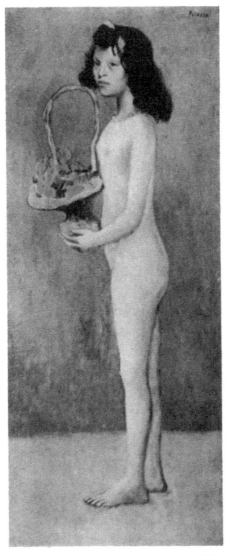

21 A LITTLE GIRL WITH A BASKET OF FLOWERS:
Rose Period (1905)

there was a tendency to cut the sky not into cubes but into arbitrary divisions, there too had been the pointilism of Seurat and his followers, but that had nothing to do with cubism, because all these other painters were preoccupied with their technique which was to express more and more what they were seeing, the seduction of things seen. Well then, from Courbet to Seurat they saw the things themselves, one may say from Courbet to Van Gogh and to Matisse they saw nature as it is, if you like, that is to say as everybody sees it.

One day they asked Matisse if, when he ate a tomato, he saw it as he painted it. No, said Matisse, when I eat it I see it as everybody sees it and it is true from Courbet to Matisse, the painters saw nature as every one sees it and their preoccupation was to express that vision, to do it with more or less tenderness, sentiment, serenity, penetration but to express it as all the world saw it.

I am always struck with the landscapes of Courbet, because he did not have to change the color to give the vision of nature as every one sees it. But Picasso was not like that, when he ate a tomato the tomato was not everybody's tomato, not at all and his effort was not to express in his way the things seen as every one sees them, but to express the thing as he was seeing it. Van Gogh at even his most fantastic moment, even when he cut off his ear, was convinced that an ear is an ear as every one could see it, the need for that ear might be something else but the ear was the same ear everybody could see.

But with Picasso, Spaniard that he is, it was entirely different. Well, Don Quixote was a Spaniard, he did

not imagine things, he saw things and it was not a dream, it was not lunacy, he really saw them.

Well Picasso is a Spaniard.

I was very much struck at this period, when cubism was a little more developed, with the way Picasso could put objects together and make a photograph of them, I have kept one of them, and by the force of his vision it was not necessary that he paint the picture. To have brought the objects together already changed them to other things, not to another picture but to something else, to things as Picasso saw them.

But as I say, Spaniards and Americans are not like Europeans, they are not like Orientals, they have something in common, that is they do not need religion or mysticism not to believe in reality as all the world knows it, not even when they see it. In fact reality for them is not real and that is why there are skyscrapers and American literature and Spanish painting and literature.

So Picasso commenced and little by little there came the picture Les Desmoiselles d'Avignon and when there was that it was too awful. I remember, Tschoukine who had so much admired the painting of Picasso was at my house and he said almost in tears, what a loss for French art.

In the beginning when Picasso wished to express heads and bodies not like every one could see them, which was the problem of other painters, but as he saw them, as one can see when one has not the habit of knowing what one is looking at, inevitably when he commenced he had the tendency to paint them as a mass as sculptors do or in profile as children do.

African art commenced in 1907 to play a part in the definition of what Picasso was creating, but in the creations of Picasso really African art like the other influences which at one time or another diverted Picasso from the way of painting which was his, African art and his French cubist comrades were rather things that consoled Picasso's vision than aided it, African art, French cubism and later Italian influence and Russian were like Sancho Panza was with Don Quixote, they wished to lead Picasso away from his real vision which was his real Spanish vision. The things that Picasso could see were the things which had their own reality, reality not of things seen but of things that exist. It is difficult to exist alone and not being able to remain alone with things, Picasso first took as a crutch African art and later other things.

Let us go back to the beginning of cubism.

He commenced the long struggle not to express what he could see but not to express the things he did not see, that is to say the things everybody is certain of seeing but which they do not really see. As I have already said, in looking at a friend one only sees one feature of her face or another, in fact Picasso was not at all simple and he analysed his vision, he did not wish to paint the things that he himself did not see, the other painters satisfied themselves with the appearance, and always the appearance, which was not at all what they could see but what they knew was there.

There is a difference.

Now the dates of this beginning.

Picasso was born in Malaga, October 25th, 1881. His parents settled definitely in Barcelona in 1895 and the young

Picasso came for the first time in 1900 to Paris where he stayed six months.

The first influence in Paris was Toulouse Lautrec, at this time and later, until his return to Paris in 1901, the influence of this first contact with Paris was quite strong, he returned there in the spring of 1901, but not to stay for long and he returned to Barcelona once more. The direct contact with Paris the second time destroyed the influences of Paris, he returned again to Barcelona and remained there until 1904 when he really became an inhabitant of Paris.

During this period, 1901 to 1904, he painted the blue pictures, the hardness and the reality which are not the reality seen, which is Spanish, made him paint these pictures which are the basis of all that he did afterwards.

In 1904 he came back to France, he forgot all the Spanish sadness and Spanish reality, he let himself go, living in the gaiety of things seen, the gaiety of French sentimentality. He lived in the poetry of his friends, Apollinaire, Max Jacob and Salmon, as Juan Gris always used to say, France seduces me and she still seduces me, I think this is so, France for Spaniards is rather a seduction than an influence.

So the harlequin or rose period was a period of enormous production, the gaiety of France induced an unheard of fecondity. It is extraordinary the number and size of the canvases he painted during this short period, 1904–1906.

Later one day when Picasso and I were discussing the dates of his pictures and I was saying to him that all that could not have been painted during one year Picasso

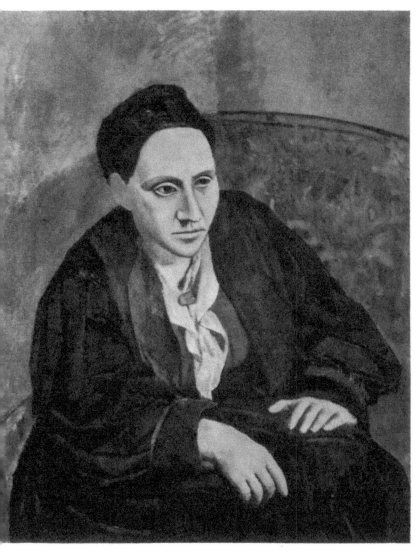

22 PORTRAIT OF MISS GERTRUDE STEIN (1906)

answered, you forget we were young and we did a great deal in a year.

Really it is difficult to believe that the harlequin period only lasted from 1904 to 1906, but it is true, there is no denying it, his production upon his first definite contact with France was enormous. This was the rose period.

The rose period ended with my portrait, the quality of drawing had changed and his pictures had already commenced to be less light, less joyous. After all Spain is Spain and it is not France and the twentieth century in France needed a Spaniard to express its life and Picasso was destined for this. Really and truly.

When I say that the rose period is light and happy everything is relative, the subjects which were happy ones were a little sad, the families of the harlequins were wretched families but from Picasso's point of view it was a light happy joyous period and a period when he contented himself with seeing things as anybody did. And then in 1906 this period was over.

In 1906 Picasso worked on my portrait during the whole winter, he commenced to paint figures in colors that were almost monotone, still a little rose but mostly an earth color, the lines of the bodies harder, with a great deal of force there was the beginning of his own vision. It was like the blue period but much more felt and less colored and less sentimental. His art commenced to be much purer.

So he renewed his vision which was of things seen as he saw them.

One must never forget that the reality of the twentieth century is not the reality of the nineteenth century, not at all and Picasso was the only one in painting who felt it,

the only one. More and more the struggle to express it intensified. Matisse and all the others saw the twentieth century with their eyes but they saw the reality of the nineteenth century, Picasso was the only one in painting who saw the twentieth century with his eyes and saw its reality and consequently his struggle was terrifying, terrifying for himself and for the others, because he had nothing to help him, the past did not help him, nor the present, he had to do it all alone and, as in spite of much strength he is often very weak, he consoled himself and allowed himself to be almost seduced by other things which led him more or less astray.

Upon his return from a short trip to Spain, he had spent the summer at Gosol, he returned and became acquainted with Matisse through whom he came to know African sculpture. After all one must never forget that African sculpture is not naïve, not at all, it is an art that is very very conventional, based upon tradition and its tradition is a tradition derived from Arab culture. The Arabs created both civilisation and culture for the negroes and therefore African art which was naïve and exotic for Matisse was for Picasso, a Spaniard, a thing that was natural, direct and civilised.

So then it was natural that this reinforced his vision and helped him to realise it and the result was the studies which brought him to create the picture of Les Desmoiselles d'Avignon.

Again and again he did not recommence but he continued after an interruption. This is his life.

It was about this period that his contact with Derain and Braque commenced and little by little pure cubism came to exist.

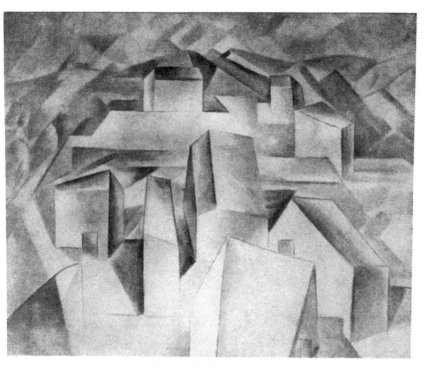

23 VILLAGE IN TARRAGONA (1909)

24 WOOD ENGRAVING (1905)

25 WOOD ENGRAVING (1905)

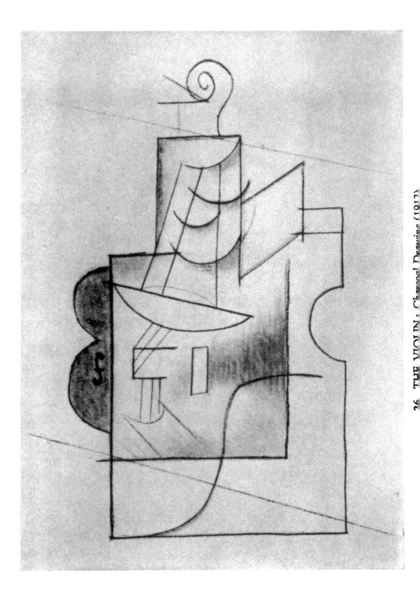

26. THE VIOLIN. Charcoal Drawing (1912)

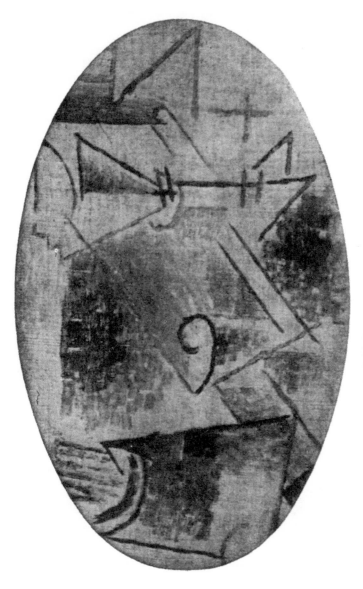

27　STILL-LIFE WITH GLASS (*Spring, 1912*)

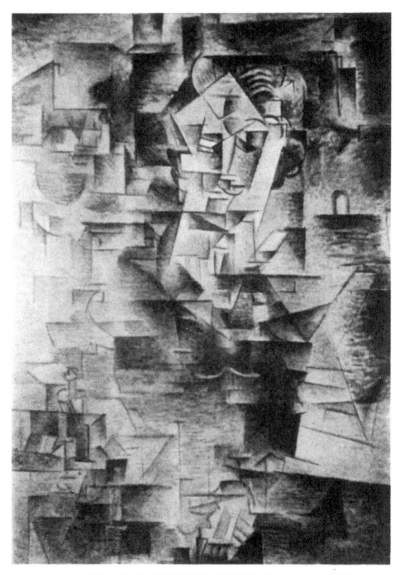

28 PORTRAIT OF HENRY KAHNWEILER (*Autumn*, 1910)

First there was the effort, still more difficult than with still lifes and landscapes, to create human beings in cubes, exhausted, Picasso emptied himself during 1907 and calmed himself by doing sculpture. Sculpture always has the bother that one can go all around it and the material of which it is made gives an impression of form before the sculptor has worked on it.

I myself prefer painting.

Picasso having made a prodigious effort to create painting by his understanding of African sculpture was seduced a short time after 1908 by his interest in the sculptural form rather than by the vision in African sculpture but even so in the end it was an intermediate step toward cubism.

Cubism is a part of the daily life in Spain, it is in Spanish architecture. The architecture of other countries always follows the line of the landscape, it is true of Italian architecture and of French architecture, but Spanish architecture always cuts the lines of the landscape and it is that that is the basis of cubism, the work of man is not in harmony with the landscape, it opposes it and it is just that that is the basis of cubism and that is what Spanish cubism is. And that was the reason for putting real objects in the pictures, the real newspaper, the real pipe. Little by little, after these cubist painters had used real objects, they wanted to see if by the force of the intensity with which they painted some of these objects, a pipe, a newspaper, in a picture, they could not replace the real by the painted objects which would by their realism require the rest of the picture to oppose itself to them.

Nature and man are opposed in Spain, they agree in

France and this is the difference between French cubism and Spanish cubism and it is a fundamental difference.

So then Spanish cubism is a necessity, of course it is.

So now it is 1908 and once more Picasso is in Spain and he returned with the landscapes of 1909 which were the beginning of classic and classified cubism.

These three landscapes express exactly what I wish to make clear, that is to say the opposition between nature and man in Spain. The round is opposed to the cube, a small number of houses gives the impression of a great quantity of houses in order to dominate the landscape, the landscape and the houses do not agree, the round is opposed to the cube, the movement of the earth is against the movement of the houses, in fact the houses have no movement because the earth has its movement, of course the houses should have none.

I have here before me a picture of a young French painter, he too with few houses creates his village, but here the houses move with the landscape, with the river, here they all agree together, it is not at all Spanish.

Spaniards know that there is no agreement, neither the landscape with the houses, neither the round with the cube, neither the great number with the small number, it was natural that a Spaniard should express this in the painting of the twentieth century, the century where nothing is in agreement, neither the round with the cube, neither the landscape with the houses, neither the large quantity with the small quantity. America and Spain have this thing in common, that is why Spain discovered America and America Spain, in fact it is for this reason that both of them have found their moment in the twentieth century.

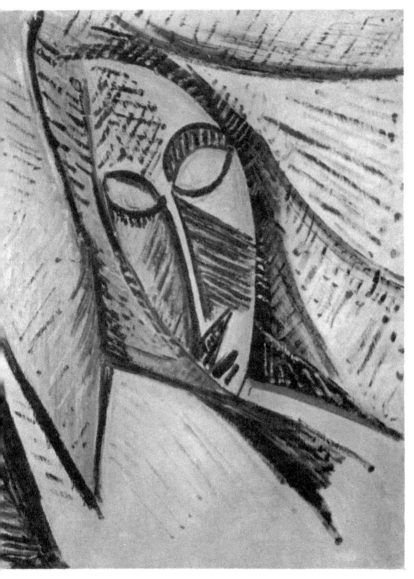

29 HEAD OF A WOMAN (1913)

So Picasso returned from Spain after a summer spent in Barcelona and in Orta de Ebro and he was once again in the rue Ravignan, but it was the beginning of the end of the rue Ravignan, actually he did not leave the rue Ravignan until 1910, but the return in 1909 was really the end of the rue Ravignan which had given him all that it would give him, that was over and now began the happy era of cubism. There was still a great deal of effort, the continual effort of Picasso to express the human form, that is to say the face, the head, the human body in the composition which he had then reached, the features seen separately existed separately and at the same time it all was a picture, the struggle to express that at this time was happy rather than sad. The cubists found a picture dealer, the young Kahnweiler, coming from London, full of enthusiasm, wishing to realise his dream of becoming a picture dealer, and hesitating a little here and there and definitely becoming interested in Picasso. In 1907 and in 1908, in 1909 and in 1910, he made contracts with the cubists, one after the other, French and Spanish and he devoted himself to their interests. The life of the cubists became very gay, the gaiety of France once again seduced Picasso, every one was gay, there were more and more cubists, the joke was to speak of some one as the youngest of the cubists, cubism was sufficiently accepted now that one could speak of the youngest of the cubists, after all he did exist and every one was gay. Picasso worked enormously as he always worked, but every one was gay.

This gaiety lasted until he left Montmartre in 1912. After that not one of them was ever so gay again. Their gaiety then was a real gaiety.

He left the rue Ravignan, 1911, to move to the boulevard de Clichy and he left the boulevard de Clichy and Montmartre to settle in Montparnasse in 1912. Life between 1910 and 1912 was very gay, it was the period of the Ma Jolie picture, it was the period of all those still lifes, the tables with their grey color, with their infinite variety of greys, they amused themselves in all sorts of ways, they still collected African sculpture but its influence was not any longer very marked, they collected musical instruments, objects, pipes, tables with fringes, glasses, nails, and at this time Picasso commenced to amuse himself with making pictures out of zinc, tin, pasted paper. He did not do any sculpture, but he made pictures with all these things. There is only one left of those made of paper and that he gave me one day and I had it framed inside a box. He liked paper, in fact everything at this time pleased him and everything was going on very livelily and with an enormous gaiety.

Everything continued but there were interruptions, Picasso left Montmartre in 1912 and gaiety was over everything continued, everything always continues but Picasso was never again so gay, the gay moment of cubism was over.

He left Montmartre for Montparnasse, first the boulevard Raspail, then the rue Schoelcher and finally Montrouge.

During all this time he did not return to Spain but during the summer he was at Ceret or at Sorgues, the beginning of life in Montparnasse was less gay, he worked enormously as he always does. It was at the rue Schoelcher that he commenced to paint with Ripolin paints, he commenced to use a kind of wall paper as a background and a small

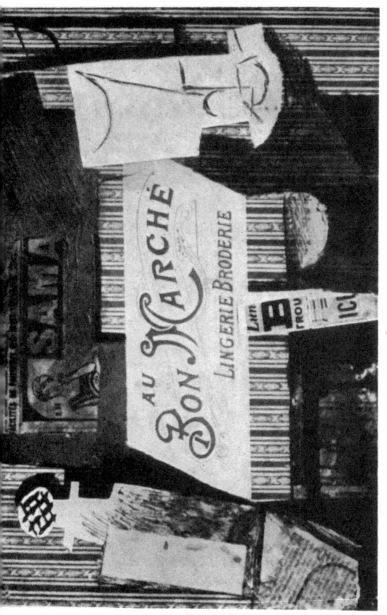

30 "AU BON MARCHÉ" : *Oils and Cut Paper (Spring, 1913)*

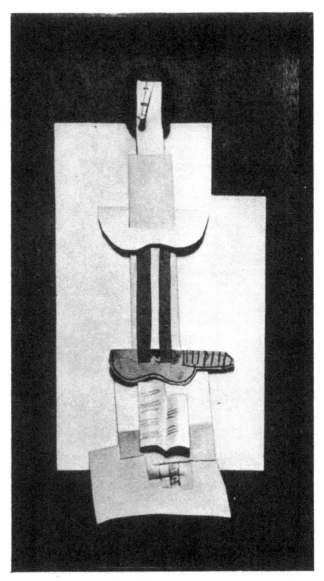

31 L'HOMME AU LIVRE : *Composition in Cut Paper* (1913)

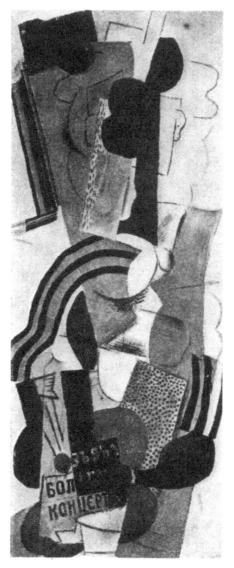

32 NATURE MORTE AUX LETTRES RUSSES (1914)

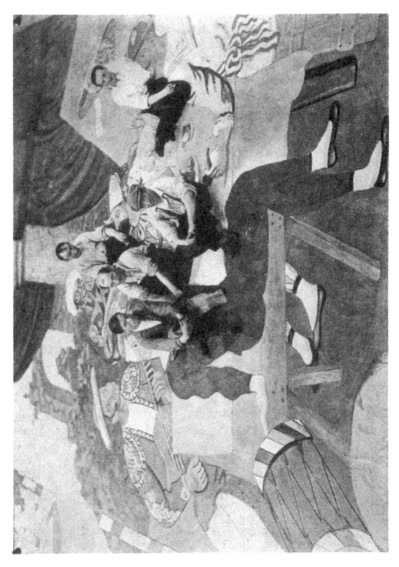

33. «PARADE.» The stage and its Actionists before the Scenery (1917)

picture painted in the middle, he commenced to use pasted paper more and more in painting his pictures. Later he used to say quite often, paper lasts quite as well as paint and after all if it all ages together, why not, and he said further, after all, later, no one will see the picture, they will see the legend of the picture, the legend that the picture has created, then it makes no difference if the picture lasts or does not last. Later they will restore it, a picture lives by its legend, not by anything else. He was indifferent as to what might happen to his pictures even though what might happen to them affected him profoundly, well that is the way one is, why not, one is like that.

Very much later when he had had a great deal of success he said one day, you know, your family, everybody, if you are a genius and unsuccessful, everybody treats you as if you were a genius, but when you come to be successful, when you commence to earn money, when you are really successful, then your family and everybody no longer treats you like a genius, they treat you like a man who has become successful.

So success had begun, not a great success, but enough success.

At this time, he was still at the rue Schoelcher, and Picasso for the first time used the Russian alphabet in his pictures. It is to be found in a few of the pictures of this period, of course this was long before his contact with the Russian ballet. So life went on. His pictures became more and more brilliant in color, more and more carefully worked and perfected and then there was war, it was 1914.

At this period his pictures were very brilliant in color, he painted musical instruments and musical signs, but the

cubic forms were continually being replaced by surfaces and lines, the lines were more important than anything else, they lived by and in themselves. He painted his pictures not by means of his objects but by the lines, at this time this tendency became more and more pronounced.

Then there was the war and all his friends left to go to the war.

Picasso was still at the rue Schoelcher, Braque and Derain were mobilised and at the front but Apollinaire had not yet gone, he was not French so he was not called but shortly after he did volunteer. Everybody had gone. Picasso was alone. Apollinaire's leaving perhaps affected him the most, Apollinaire who wrote him all his feelings in learning to become a warrior, that was then 1914 and now it was all war.

Later he moved from the rue Schoelcher to Montrouge and it was during this moving that the objects made of paper and zinc and tin were lost and broken. Later at Montrouge he was robbed, the burglars took his linen. It made me think of the days when all of them were unknown and when Picasso said that it would be marvellous if a real thief came and stole his pictures or his drawings. Friends, to be sure, took some of them, stole them if you like from time to time, pilfered if you like, but a real professional burglar, a burglar by profession, when Picasso was not completely unknown, came and preferred to taken the linen.

So little by little time passed. Picasso commenced to know Erik Satie and Jean Cocteau and the result was Parade, that was the end of this period, the period of real cubism.

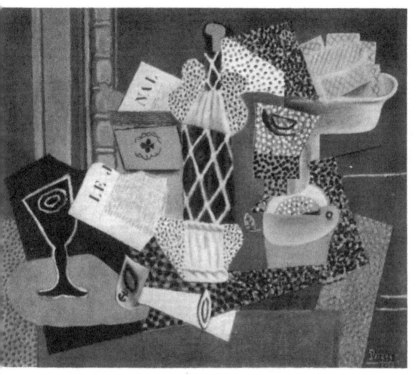

34 LA BOUTEILLE DE MARASQUIN (1914)

Jean Cocteau left for Rome with Picasso, 1917, to prepare Parade. It was the first time that I saw Cocteau, they came together to say good-bye, Picasso was very gay, not so gay as in the days of the great cubist gaiety but gay enough, he and Cocteau were gay, Picasso was pleased to be leaving, he had never seen Italy. He never had enjoyed travelling, he always went where others already were, Picasso never had the pleasure of initiative. As he used to say of himself, he has a weak character and he allowed others to make decisions, that is the way it is, it was enough that he should do his work, decisions are never important, why make them.

So cubism was to be put on the stage. That was really the beginning of the general recognition of Picasso's work, when a work is put on the stage of course every one has to look at it and in a sense if it is put on the stage every one is forced to look and since they are forced to look at it, of course, they must accept it, there is nothing else to do. In the spring of 1917 Picasso was in Italy with Diaghelew and with Cocteau and he made the stage settings and the costumes for Parade which is completely cubist. It had a great success, it was produced and accepted, of course, from the moment it was put on the stage, of course, it was accepted.

So the great war continued but it was nearing its end, and the war of cubism, it too was commencing to end, no war is ever ended, of course not, it only has the appearance of stopping. So Picasso's struggle continued but for the moment it appeared to have been won by himself for himself and by him for the world.

It is an extraordinary thing but it is true, wars are only a means of publicising the things already accomplished, a

change, a complete change, has come about, people no longer think as they were thinking but no one knows it, no one recognises it, no one really knows it except the creators. The others are too busy with the business of life, they cannot feel what has happened, but the creator, the real creator, does nothing, he is not concerned with the activity of existing, and as he is not active, that is to say as he is not concerned with the activity of existence he is sensitive enough to understand how people are thinking, he is not interested in knowing how they were thinking, his sensitive feeling is concerned in understanding how people live as they are living. The spirit of everybody is changed, of a whole people is changed, but mostly nobody knows it and a war forces them to recognise it because during a war the appearance of everything changes very much quicker, but really the entire change has been accomplished and the war is only something which forces everybody to recognise it. The French revolution was over when war forced everybody to recognise it, the American revolution was accomplished before the war, the war is only a publicity agent which makes every one know what has happened, yes, it is that.

So then the public recognises a creator who has seen the change which has been accomplished before a war and which has been expressed by the war, and by the war the world is forced to recognise the entire change in everything, they are forced to look at the creator who, before any one, knew it and expressed it. A creator is not in advance of his generation but he is the first of his contemporaries to be conscious of what is happening to his generation.

A creator who creates, who is not an academician, who

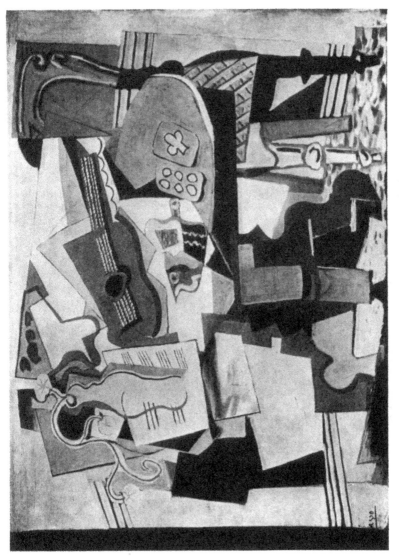

35 STILL-LIFE WITH VIOLIN (1920)

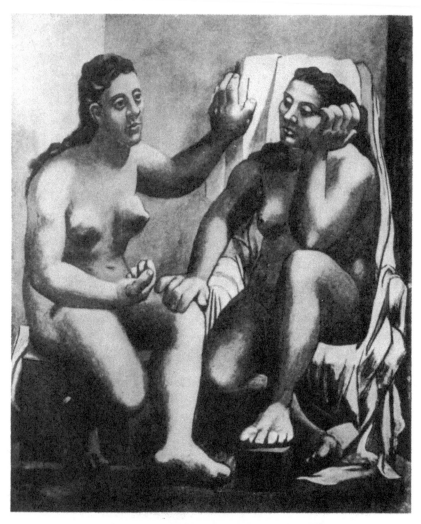

36 TWO NUDES WITH DRAPERY (1920)

is not some one who studies in a school where the rules are already known, and of course being known they no longer exist, a creator then who creates is necessarily of his generation. His generation lives in its contemporary way but they only live in it. In art, in literature, in the theatre, in short in everything that does not contribute to their immediate comfort they live in the preceding generation. It is very simple, to-day in the streets of Paris, horses, even tramcars can no longer exist but horses and tramcars are only suppressed only when they cause too many complications, they are suppressed but sixty years too late. Lord Grey said when the war broke out that the generals thought of a war of the nineteenth century even when the instruments of war were of the twentieth century and only when the war was at its heighth did the generals understand that it was a war of the twentieth century and not a war of the nineteenth century. That is what the academic spirit is, it is not contemporary, of course not, and so it can not be creative because the only thing that is creative in a creator is the contemporary thing. Of course.

As I was saying, in the daily living it is another thing. A friend built a modern house and he suggested that Picasso too should have one built. But, said Picasso, of course not, I want an old house. Imagine, he said, if Michael Angelo would have been pleased if some one had given him a fine piece of Renaissance furniture, not at all. He would have been pleased if he had been given a beautiful Greek intaglio, of course.

So that is the way it is, a creator is so completely contemporary that he has the appearance of being ahead of his

generation and to calm himself in his daily living he wishes to live with the things in the daily life of the past, he does not wish to live as contemporary as the contemporaries who do not poignantly feel being contemporary. This sounds complicated but it is very simple.

So when the contemporaries were forced by the war to recognise cubism, cubism as it had been created by Picasso who saw a reality that was not the vision of the nineteenth century, which was not a thing seen but felt, which was a thing that was not based upon nature but opposed to nature like the houses in Spain are opposed to the landscape, like the round is opposed to cubes. Every one was forced by the war which made them understand that things had changed to other things and that they had not stayed the same things, they were forced then to accept Picasso. Picasso returned from Italy and freed by Parade, which he had just created, he became a realistic painter, he even made many portraits from models, portraits which were purely realistic. It is evident that really nothing changes but at the same time everything changes and Italy and Parade and the termination of the war gave to Picasso in a kind of a way another harlequin period, a realistic period, not sad, less young, if you like, but a period of calm, he was satisfied to see things as everybody saw them, not completely as everybody does but completely enough. Period of 1917 to 1920.

Picasso was always possessed by the necessity of emptying himself, of emptying himself completely, of always emptying himself, he is so full of it that all his existence is the repetition of a complete emptying, he must empty himself, he can never empty himself of being Spanish, but he can

empty himself of what he has created. So every one says that he changes but really it is not that, he empties himself and the moment he has completed emptying himself he must recommence emptying himself, he fills himself up again so quickly.

Twice in his life he almost emptied himself of being Spanish, the first time during his first real contact with Paris when there came the harlequin or rose period, 1904–1906, the second time was his contact with the theatre, that was the realistic period which lasted from 1918 to 1921. During this period he painted some very beautiful portraits, some paintings and some drawings of harlequins and many other pictures. This adult rose period lasted almost three years.

But of course the rose period could not persist in him. He emptied himself of the rose period and inevitably it changed to something else, this time it changed to the period of large women and later to one of classic subjects, women with draperies, perhaps this was the commencement of the end of this adult rose period.

There certainly have been two rose periods in the life of Picasso. During the second rose period there was almost no real cubism but there was painting which was writing which had to do with the Spanish character, that is to say the Saracen character and this commenced to develop very much.

I will explain.

In the Orient calligraphy and the art of painting and sculpture have always been very nearly related, they resemble each other, they help each other, they complete each other. Saracen architecture was decorated with

letters, with words in Sanskrit letters, in China the letters were something in themselves. But in Europe the art of calligraphy was always a minor art, decorated by painting, decorated by lines, but the art of writing and the decoration by writing and the decoration around writing are always a minor art. But for Picasso, a Spaniard, the art of writing, that is to say calligraphy, is an art. After all the Spaniards and the Russians are the only Europeans who are really a little Oriental and this shows in the art of Picasso, not as anything exotic but as something quite profound. It is completely assimilated, of course he is a Spaniard, and a Spaniard can assimilate the Orient without imitating it, he can know Arab things without being seduced, he can repeat African things without being deceived.

The only things that really seduce the Spaniards are Latin things, French things, Italian things, for them the Latin is exotic and seductive, it is the things the Latins make which for the Spaniards are charming. As Juan Gris always said, the school of Fontainebleau was completely a seduction, it was of course completely Latin, Italy in France.

So then the Italian seduction resulted for Picasso after his first visit to Rome in his second rose period which commenced in 1918 with the portrait of his wife and lasted until the portrait of his son in harlequin costume in 1927, and all this began with portraits, then the large women, to end with classic subjects. It was once more Latin seduction this time by means of Italy. But above all it was always and always Spain and it was Spain which impelled him even during this naturalistic period to express himself by calligraphy in his pictures.

34

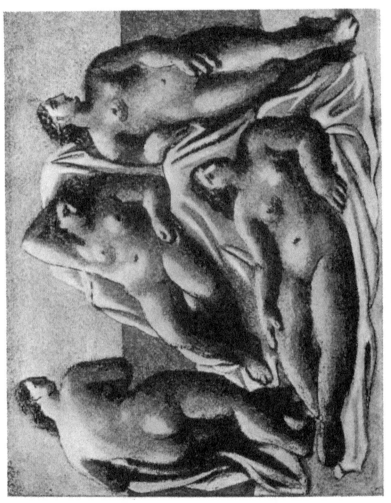

37 THE BATHERS (1921)

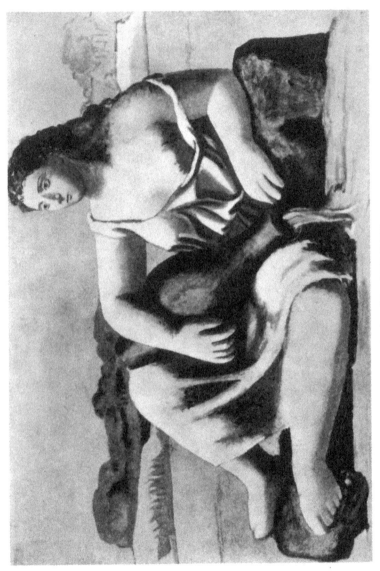

38 LA SOURCE (1921)

The first thing I saw that showed this calligraphic quality in Picasso were several wood-cuts which he had made during the harlequin period, that first rose period of 1904. There were two birds made in a single stroke and colored with only one color. Beside these two small things I do not remember any other things of his which were really calligraphic until his last period of pure cubism, that is to say from 1912 to 1917.

During this period the cubes were no longer important, the cubes were lost. After all one must know more than one sees and one does not see a cube in its entirety. In 1914 there were less cubes in cubism, each time that Picasso commenced again he recommenced the struggle to express in a picture the things seen without association but simply as things seen and it is only the things seen that are knowledge for Picasso. Related things are things remembered and for a creator, certainly for a Spanish creator, certainly for a Spanish creator of the twentieth century, remembered things are not things seen, therefore they are not things known. And so then always and always Picasso commenced his attempt to express not things felt, not things remembered, not established in relations but things which are there, really everything a human being can know at each moment of his existence and not an assembling of all his experiences. So that during all this last period of pure cubism, 1914–1917, he tried to recommence his work, at the same time he became complete master of his metier. It was the interval between 1914 and 1917 when his mastery of his technique became so complete that it reached perfection, there was no longer any hesitation, now when he knew what to do he could do what he

wanted to do, no technical problem stopped him. But after all, this problem remained, how to express not the things seen in association but the things really seen, not things interpreted but things really known at the time of knowing them. All his life this had been his problem but the problem had become more difficult than ever, now that he was completely master of his technique he no longer had any real distraction, he could no longer have the distraction of learning, his instrument was perfected.

At this period, from 1913 to 1917, his pictures have the beauty of complete mastery. Picasso nearly did all that he wanted to do, he put into his pictures nearly nothing that should not have been there, there were no cubes, there were simply things, he succeeded in only putting into them what he really knew and all that ended with the voyage to Italy and the preparation of Parade.

After Italy and Parade he had his second naturalistic period of which anybody could recognise the beauty and his technique which was now perfected permitted him to create this beauty with less effort, this beauty existed in itself.

These pictures have the serenity of perfect beauty but they have not the beauty of realisation. The beauty of realisation is a beauty that always takes more time to show itself as beauty than pure beauty does. The beauty of realisation during its creation is not beauty, it is only beauty when the things that follow it are created in its image. It is then that it is known as beauty on account of its quality of fecondity, it is the most beautiful beauty, more beautiful than the beauty of serenity. Well.

After Italy and Parade Picasso married and in 1918 he

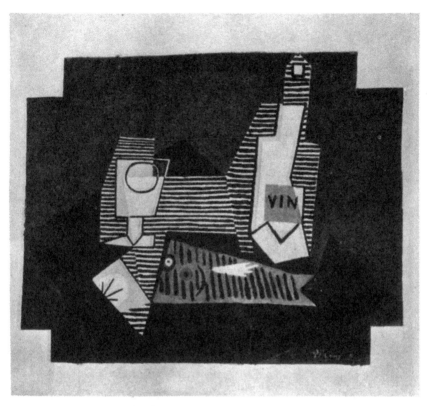

39 A BOTTLE OF WINE (1922)

40 STILL LIFE IN OPPOSING COLOURS (1922)

left Montrouge for the rue de la Boëtie, he stayed there until 1937 and during this time, 1919 to 1937, there were many things created, many things happened to the painting of Picasso.

But let us return to calligraphy and its importance in Picasso's art.

It was natural that the cubism of 1913 to 1917 revealed the art of calligraphy to him, the importance of calligraphy seen as Orientals see it and not as Europeans see it. The contact with Russia, first through a Russian G. Apostrophe as they all called him, and later with the Russian ballet, stimulated his feeling for calligraphy which is always there in a Spaniard always since Spaniards have had for such a long time Saracen art always with them.

And also one must never forget that Spain is the only country in Europe whose landscape is not European, not at all, therefore it is natural that although Spaniards are Europeans even so they are not Europeans.

So in all this period of 1913 to 1917 one sees that he took great pleasure in decorating his pictures, always with a rather calligraphic tendency than a sculptural one, and during the naturalist period, which followed Parade and the voyage to Italy, the consolation offered to the side of him that was Spanish was calligraphy. I remember very well in 1923 he did two women completely in this spirit, a very little picture but all the reality of calligraphy was in it, everything that he could not put into his realistic pictures was there in the two calligraphic women and they had an extraordinary vitality.

Calligraphy, as I understand it in him had perhaps its most intense moment in the *décor* of Mercure. That was

37

written, so simply written, no painting, pure calligraphy. A little before that he had made a series of drawings, also purely calligraphic, the lines were extraordinarily lines, there were also stars that were stars which moved, they existed, they were really cubism, that is to say a thing that existed in itself without the aid of association or emotion.

During all this time the realistic period was commencing to approach its end, first there had been portraits which ended with harlequins, for once Picasso had almost wished to look at models. The naturalistic painting changed to the large women, at first women on the shore or in the water, with a great deal of movement, and little by little the large women became very sculpturesque. In this way Picasso emptied himself of Italy. That is his way.

During the year 1923 his pleasure in drawing was enormous, he almost repeated the fecondity and the happiness of his first rose period, everything was in rose. That ended in 1923. It was at this time that the classic period commenced, it was the end of Italy, it still showed in his drawings but in his painting he had completely purged himself of Italy, really entirely.

Then came the period of the large still-lifes, 1927, and then for the first time in his life six months passed without his working. It was the very first time in his life.

It is necessary to think about this question of calligraphy, it must never be forgotten that the only way Picasso has of speaking, the only way Picasso has of writing is with drawings and paintings. In 1914 and from then on it never stopped, he had a certain way of writing his thoughts, that is to say of seeing things in a way that he knew he was seeing them. And it was in this way that he commenced

38

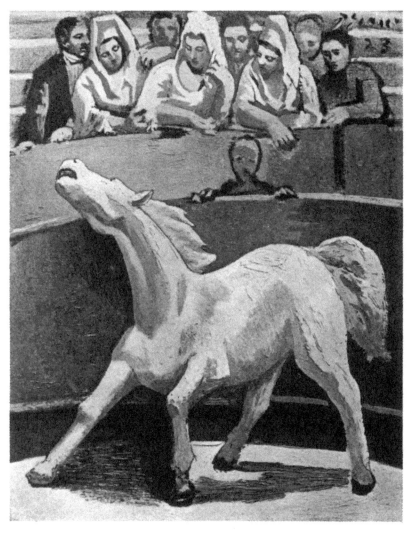

41 THE WHITE HORSE IN THE RING (1923)

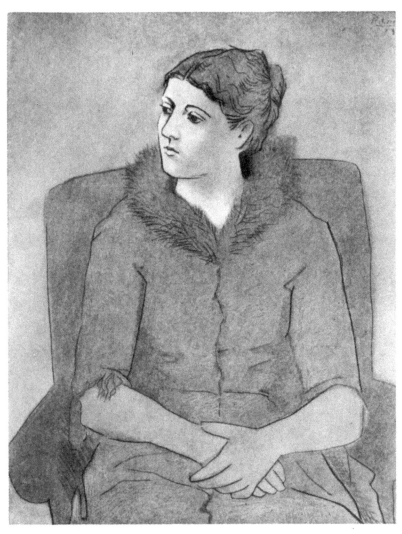

42 PORTRAIT OF MADAME PICASSO (1923)

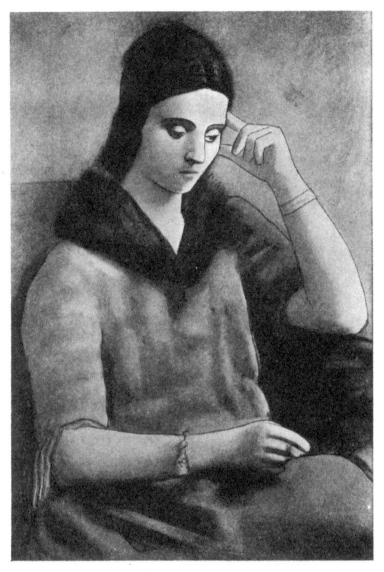

43 PORTRAIT OF MADAME PICASSO (1923)

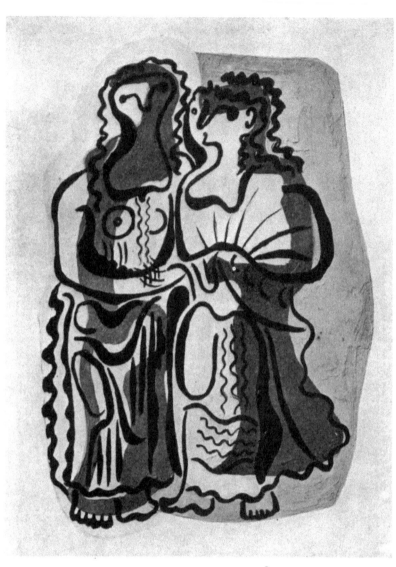

44 DEUX FEMMES CALLIGRAPHÍEES (1923)

to write these thoughts with drawings and with painting. Oriental people, the people of America and the people of Spain have never, really never forgotten that it is not necessary to use letters in order to be able to write. Really one can write in another way and Picasso has understood, completely understood this way. To recapitulate. From 1914 to 1917 cubism changed to rather flat surfaces, it was no longer sculpture, it was writing and Picasso really expressed himself in this way because it was not possible, really not, to really write with sculpture, no, not.

So it was natural that at this period, 1913 to 1917, during which time he was almost always alone, that he should recommence writing all he knew and he knew many things. As I have said, it was then he completely mastered the technique of painting. And this ended with Parade.

Now a great struggle commenced again. The influence of Italy, the influence of everybody's return from the war, the influence of a great deal of recognition and the influence of his joy at the birth of his son, precipitated him into a second rose period, a completely realistic period which lasted from 1919 to 1927. This was a rose period, it certainly was and in the same way as the first rose period it ended when Picasso commenced to strengthen and harden his lines and solidify the forms and the colors, in the same way that the first rose period changed with my portrait so this rose period changed about 1920 by painting enormous and very robust women. There was still a little the memory of Italy in its forms and draperies and this lasted until 1923 when he finished the large classical pictures. So the second rose period naturally ended in the same way as the first one had, that is to say by the triumph of Spain. It was

during all this period that he first painted, about 1920 and 1921, very highly colored cubist pictures, very calligraphic and very colored and then more and more calligraphic and less colored. During all this time the color of this cubism was pure color, Ripolin paint, which he called the health of color.

Later I will tell something about Picasso's color which too, in itself, is a whole story.

To continue.

When the second rose period changed to the period of large women, around 1923, at the same time that calligraphy was in full activity, there commenced to be felt in the large pictures and it culminated in one of these large pictures La Danse, the fact that naturalism for Picasso was dead, that he was no longer seeing as all the world thought they saw.

And as the pure period of cubism, that is to say the cubism of cubes, found its final explosion in Parade, so the pure writing of this period found its explosion in the ballet Mercure, in 1924 at the Soirées de Paris.

Then a curious story commenced, like the story of the African period and that of Les Desmoiselles d'Avignon.

Picasso had purged himself of Italy in his second rose period and the large women and the classical subjects. He always had Spain inside him, he can not purge himself of that because it is he, it is himself, so then the writing which is the continuation of cubism, if it is not the same thing, was always continuing, but now there was another thing, it was Russia, and to rid himself of that was a terrible struggle. During this struggle things seen as everybody can see them nearly dominated him and to avoid this, avoid being conquered by this, for the first time in his life, and

40

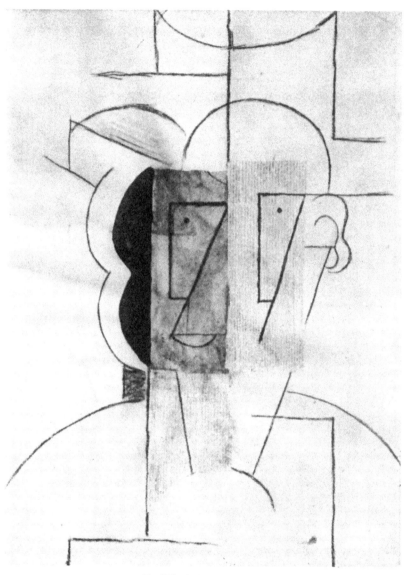

45　HEAD OF A MAN:
Drawing in Chalk and Cut Paper

46 SETTING FOR "MERCURE" (1923)

47 TORSO : *Ink Drawing* (1906)

twice since, he stopped painting, he ceased speaking as he knew how to speak, writing as he knew how to write, with drawings and with color.

We are now in 1924 and the production of Mercure.

At this time he began to do sculpture. I say that Italy was completely out of him but Russia was still in him. The art of Russia is essentially a peasant art, an art of speaking with sculpture. It requires a greater detachment to know how to speak with drawings and with color than to speak with sculpture in cubes or in round and the African sculpture was cube and the Russian sculpture was round. There is also another very important difference, the size of the features and of the people in African sculpture is a real size, the size in Russian sculpture is an abnormal one so that one art is pure and the other fantastic and Picasso a Spaniard is never fantastic, he is never pornographic but Russian art is both. Again a struggle.

The Spanish character is a mixture of Europe and the Orient, the Russian character is a mixture of the European and the Oriental but it is neither the same Europe nor the same Orient, but as it is the same mixture the struggle to become once more himself was harder than ever and from 1924 to 1935 this struggle lasted.

During this time his consolation was cubism, the harlequins big and little, and his struggle was in the large pictures where the forms in spite of being fantastic forms were forms like everybody sees them, were, if you wish, pornographic forms, in a word forms like Russians can see them but not forms like a Spaniard can see them.

As I have said and as I have repeated, the character, the vision of Picasso is like himself, it is Spanish and he does not

41

see reality as all the world sees it, so that he alone amongst the painters did not have the problem of expressing the truths that all the world can see but the truths that he alone can see and that is not the world the world recognises as the world.

As he has not the distraction of learning because he can create it the moment he knows what he sees, he having a sensitiveness and a tenderness and a weakness that makes him wish to share the things seen by everybody, he always in his life is tempted, as a saint can be tempted, to see things as he does not see them.

Again and again it has happened to him in his life and the strongest temptation was between 1925 and 1935.

The struggle was intense and sometimes almost mortal.

In 1937 he recommenced painting, he had not drawn nor painted for six months, as I have said several times the struggle was almost mortal, he must see what he saw and the reality for him had to be the reality seen not by everybody but by him and every one wished to lead him away from this, wished to force him to see what he did not see. It was like when they wanted to force Galileo to say that the earth did not turn. Yes it was that.

Just before the six months during which for the first time in his life he did not draw nor paint he had an enormous fecundity. Another way of finding himself again. An enormous production is as necessary as doing nothing in order to find one's self again, so then at first he had an enormous production and after it completely ceased during six months. During these six months the only thing he did was a picture made of a rag cut by a string, during the great moment of cubism he made such things, at that time

48 LA DANSE (1925)

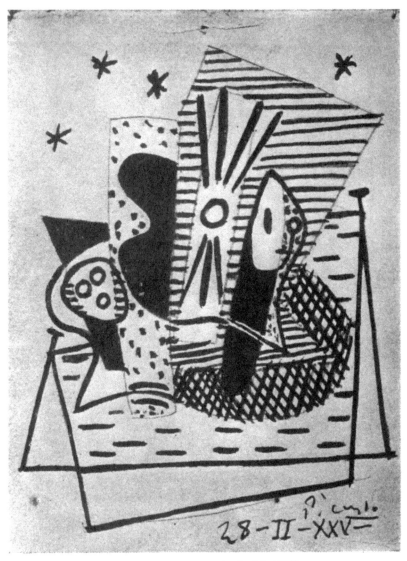

49 STILL-LIFE WITH STARS (1925)

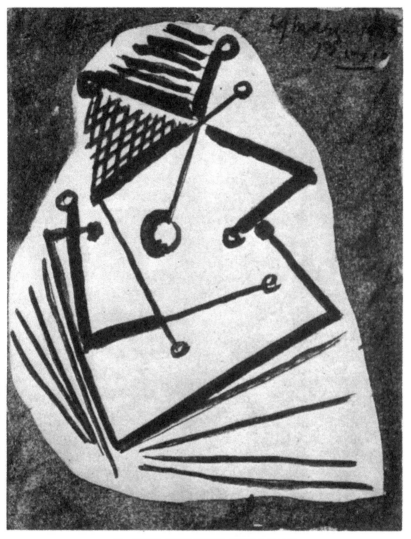

50 STILL-LIFE WITH NAILS (1925)

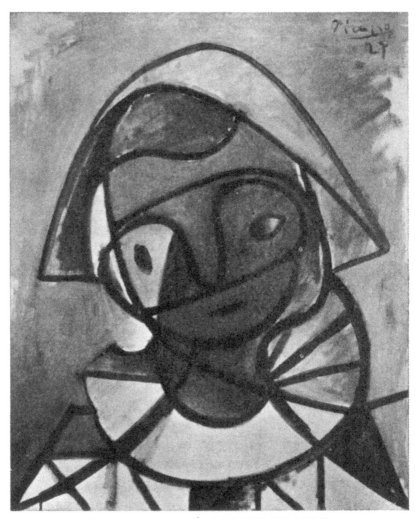

51 PORTRAIT OF THE ARTIST'S SON (1927)

it gave him great joy to do it but now it was a tragedy. This picture was beautiful, this picture was sad and it was the only one.

After this he commenced again but this time rather with sculpture than with painting, again and again he wanted to escape from those too well-known forms which were not the forms he saw and this was what induced him to make sculpture which at first was very very thin, as thin as a line, not thicker than that. That was perhaps why Greco made his figures as he did make them. Perhaps.

Almost at the same time he commenced to make enormous statues, all this to empty himself of those forms which were not forms he could see, I say that this struggle was formidable.

It was at this time, that is to say in 1933, that once more he ceased to paint but he continued to make drawings and during the summer of 1933 he made his only surrealist drawings. Surrealism could console him a little, but not really. The surrealists still see things as every one sees them, they complicate them in a different way but the vision is that of every one else, in short the complication is the complication of the twentieth century but the vision is that of the nineteenth century. Picasso only sees something else, another reality. Complications are always easy but another vision than that of all the world is very rare. That is why geniuses are rare, to complicate things in a new way that is easy, but to see the things in a new way that is really difficult, everything prevents one, habits, schools, daily life, reason, necessities of daily life, indolence, everything prevents one, in fact there are very few geniuses in the world.

Picasso saw something else, not another complication

but another thing, he did not see things evolve as people saw them evolve in the nineteenth century, he saw things evolve as they did not evolve which was the twentieth century, in other words he was contemporary with the things and he saw these things, he did not see as all the others did, as all the world thought they saw, that is to say as they themselves saw them in the nineteenth century.

During this period there was another curious thing.

The color Picasso used was always important, so important that his periods were named after the color that he was using. To commence with the commencement.

The first influence of his first short visits to Paris, 1900, gave him the color of Toulouse Lautrec, the characteristic color of the painting of that period. That lasted a very short time and when he came back to Paris and returned to Spain the colors he used were naturally Spanish, the color blue, and the pictures of this period were always blue. When he was in France again and when French gaiety made him gay he painted in rose and that is called the rose period. There was really some blue in this period but the blue had rather a rose character than a blue character, so then it was really a rose period, that was followed by the beginning of the struggle for cubism, the African period which had some rose but which turned first to beige, later to brown and red as in my portrait and after that there was an intermediary period, before real cubism and that was a rather green period. It is less known but it is very very beautiful, landscapes and large still-lifes, also some figures. After that there were pale landscapes which little by little were followed by grey still-lifes. It was during this grey period that Picasso really for the first time showed himself

44

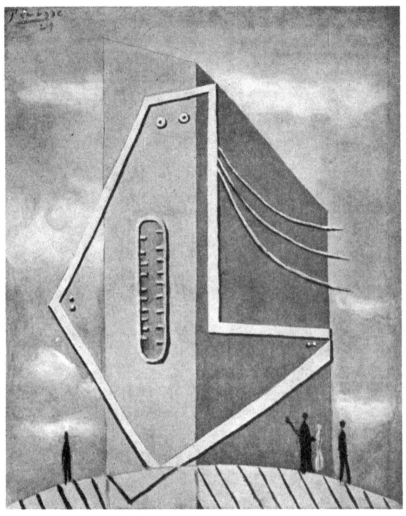

52 FEMME AU SOURIRE (1929)

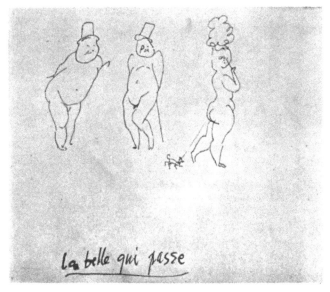

53 SURREALIST DRAWING (1933)

54 DRAWING (1905)

to be a great colorist. There is an infinite variety of grey in these pictures and by the vitality of painting the greys really become color. After that as Picasso had then really become a colorist his periods were not named after their colors.

He commenced, this was 1914, to study colors, the nature of colors, he became interested in making pure colors but the color quality which he found when he painted in grey was a little lost, later when his second naturalistic period was over he commenced again to be enormously interested in color, he played with colors to oppose the colors to the drawings, Spaniard that he was it is natural that the colors should not help the drawing but should oppose themselves to it and it was about 1923 that he interested himself enormously in this. It was also during the calligraphic period, 1923, and later that this opposition of drawing and of color was the most interesting.

Little by little when the struggle not to be subjugated by the vision which was not his vision was going on, the colors commenced to be rather the ordinary colors that other painters used, colors that go with the drawing and finally between 1927 and 1935 Picasso had a tendency to console himself with Matisse's conception of color, this was when he was most despairful that this commenced and this ended when he ceased to paint in 1935.

In fact he ceased to paint during two years and he neither painted nor drew.

It is extraordinary that one ceases to do what one has done all one's life but that can happen.

It is always astonishing that Shakespeare never put his hand to his pen once he ceased to write and one knows

other cases, things happen that destroy everything which forced the person to exist and the identity which was dependent upon the things that were done, does it still exist, yes or no.

Rather yes, a genius is a genius, even when he does not work.

So Picasso ceased to work.

It was very curious.

He commenced to write poems but this writing was never his writing. After all the egoism of a painter is not at all the egoism of a writer, there is nothing to say about it, it is not. No.

Two years of not working. In a way Picasso liked it, it was one responsibility the less, it is nice not having responsibilities, it is like the soldiers during a war, a war is terrible, they said, but during a war one has no responsibility, neither for death, nor for life. So these two years were like that for Picasso, he did not work, it was not for him to decide every moment what he saw, no, poetry for him was something to be made during rather bitter meditations, but agreably enough, in a café.

This was his life for two years, of course he who could write, write so well with drawings and with colors, knew very well that to write with words was, for him, not to write at all. Of course he understood that but he did not wish to allow himself to be awakened, there are moments in life when one is neither dead nor alive and for two years Picasso was neither dead nor alive, it was not an agreeable period for him, but a period of rest, he, who all his life needed to empty himself and to empty himself, during two years he did not empty himself, that is to say not actively,

55 LANDSCAPE (1937)

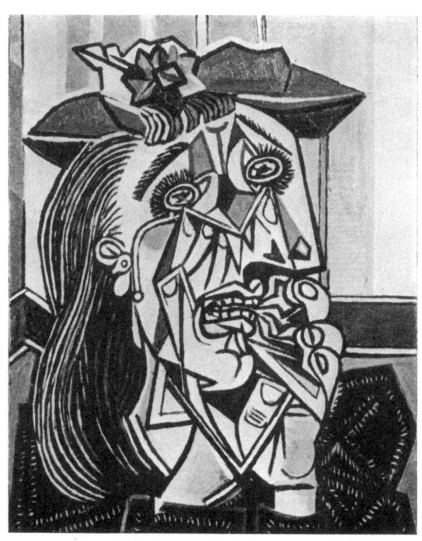

56 LA FEMME QUI PLEURE (1938)

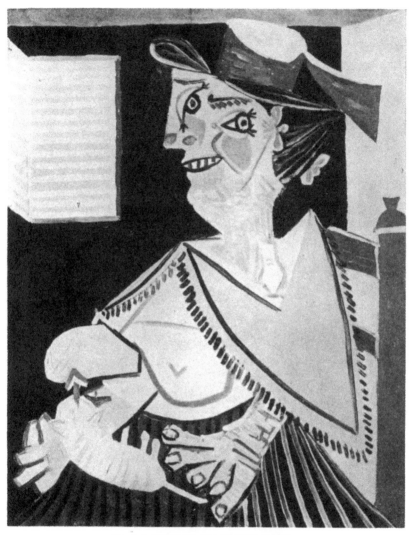

57 LA FEMME AU FICHU (1938)

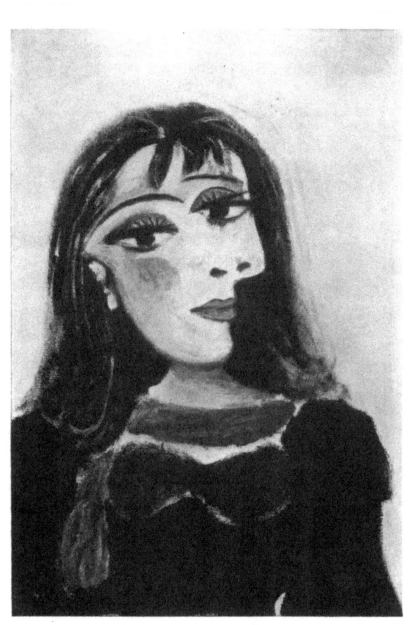

58 WOMAN WITH LONG HAIR (1938)

actually he really emptied himself completely, emptied himself of many things and above all of being subjugated by a vision which was not his own vision.

As I have said Picasso knows, really knows the faces, the heads, the bodies of human beings, he knows them as they have existed since the existence of the human race, the soul of people does not interest him, why interest one's self in the souls of people when the face, the head, the body can tell everything, why use words when one can express everything by drawings and colors. During this last period, from 1927 to 1935, the souls of people commenced to dominate him and his vision, a vision which was as old as the creation of people, lost itself in interpretation. He who could see did not need interpretation and in these years, 1927 to 1935, for the first time, the interpretations destroyed his own vision so that he made forms not seen but conceived. All this is difficult to put into words but the distinction is plain and clear, it is why he stopped working. The only way to purge himself of a vision which was not his was to cease to express it, so that as it was impossible for him to do nothing he made poetry but of course it was his way of falling asleep during the operation of detaching himself from the souls of things which were not his concern.

To see people as they have existed since they were created is not strange, it is direct, and Picasso's vision, his own vision, is a direct vision.

Finally war broke out in Spain.

First the revolution and then war.

It was not the events themselves that were happening in Spain which awoke Picasso but the fact that they were happening in Spain, he had lost Spain and here was Spain

not lost, she existed, the existence of Spain awakened Picasso, he too existed, everything that had been imposed upon him no longer existed, he and Spain, both of them existed, of course they existed, they exist, they are alive, Picasso commenced to work, he commenced to speak as he has spoken all his life, speaking with drawings and color, speaking with writing, the writing of Picasso.

All his life he has only spoken like that, he has written like that, and he has been eloquent.

So in 1937 he commenced to be himself again.

He painted a large picture about Spain and it was written in a calligraphy continuously developed and which was the continuation of the great advancement made by him in 1922, now he was in complete effervescence, and at the same time he found his color. The color of the pictures he paints now in 1937 are bright colors, light colors but which have the qualities of the colors which until now only existed in his greys, the colors can oppose the drawing, they can go together with the drawing, they can do what they want, it is not that they can agree or not with the drawing that they are there, they are there only to exist, certainly Picasso has now found his color, his real color in 1937.

Now this is the end of this story, not the end of his story, but the end of this story of his story.

EPILOGUE

To-day the pictures of Picasso have come back to me from the exhibition at the Petit Palais and once more they are on my walls, I can not say that during their absence I forgot their splendor but they are more splendid than that. The twentieth century is more splendid than the nineteenth

48

59 PICASSO
From a Photograph by Cecil Beaton

60 GERTRUDE STEIN
From a Photograph by Cecil Beaton

century, certainly it is much more splendid. The twentieth century has much less reasonableness in its existence than the nineteenth century but reasonableness does not make for splendor. The seventeenth century had less reason in its existence than the sixteenth century and in consequence it has more splendor. So the twentieth century is that, it is a time when everything cracks, where everything is destroyed, everything isolates itself, it is a more splendid thing than a period where everything follows itself. So then the twentieth century is a splendid period, not a reasonable one in the scientific sense, but splendid. The phenomena of nature are more splendid than the daily events of nature, certainly, so then the twentieth century is splendid.

It was natural that it was a Spaniard who understood that a thing without progress is more splendid than a thing which progresses. The Spaniards who adore mounting a hill at full speed and coming down hill slowly, it is they who were made to create the painting of the twentieth century, and they did it, Picasso did it.

One must not forget that the earth seen from an airplane is more splendid than the earth seen from an automobile. The automobile is the end of progress on the earth, it goes quicker but essentially the landscapes seen from an automobile are the same as the landscapes seen from a carriage, a train, a waggon, or in walking. But the earth seen from an airplane is something else. So the twentieth century is not the same as the nineteenth century and it is very interesting knowing that Picasso has never seen the earth from an airplane, that being of the twentieth century he inevitably knew that the earth is not the same as in the nineteenth

century, he knew it, he made it, inevitably he made it different and what he made is a thing that now all the world can see. When I was in America I for the first time travelled pretty much all the time in an airplane and when I looked at the earth I saw all the lines of cubism made at a time when not any painter had ever gone up in an airplane. I saw there on the earth the mingling lines of Picasso, coming and going, developing and destroying themselves, I saw the simple solutions of Braque, I saw the wandering lines of Masson, yes I saw and once more I knew that a creator is contemporary, he understands what is contemporary when the contemporaries do not yet know it, but he is contemporary and as the twentieth century is a century which sees the earth as no one has ever seen it, the earth has a splendor that it never has had, and as everything destroys itself in the twentieth century and nothing continues, so then the twentieth century has a splendor which is its own and Picasso is of this century, he has that strange quality of an earth that one has never seen and of things destroyed as they have never been destroyed. So then Picasso has his splendor.

Yes. Thank you.

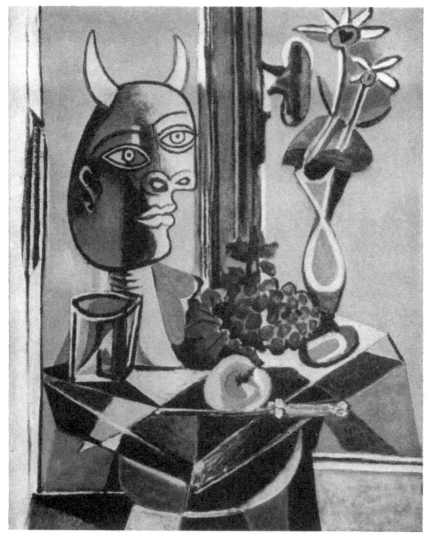

61 STILL-LIFE WITH GRAPES (1938)
In the Artist's Studio

INDEX

(The numerals in italics refer to the *figure numbers* of illustrations)

A CATALOG OF SELECTED
DOVER BOOKS
IN ALL FIELDS OF INTEREST

A CATALOG OF SELECTED DOVER
BOOKS IN ALL FIELDS OF INTEREST

100 BEST-LOVED POEMS, Edited by Philip Smith. "The Passionate Shepherd to His Love," "Shall I compare thee to a summer's day?" "Death, be not proud," "The Raven," "The Road Not Taken," plus works by Blake, Wordsworth, Byron, Shelley, Keats, many others. 96pp. 5³⁄₁₆ x 8¼. 0-486-28553-7

100 SMALL HOUSES OF THE THIRTIES, Brown-Blodgett Company. Exterior photographs and floor plans for 100 charming structures. Illustrations of models accompanied by descriptions of interiors, color schemes, closet space, and other amenities. 200 illustrations. 112pp. 8⅜ x 11. 0-486-44131-8

1000 TURN-OF-THE-CENTURY HOUSES: With Illustrations and Floor Plans, Herbert C. Chivers. Reproduced from a rare edition, this showcase of homes ranges from cottages and bungalows to sprawling mansions. Each house is meticulously illustrated and accompanied by complete floor plans. 256pp. 9⅜ x 12¼.

0-486-45596-3

101 GREAT AMERICAN POEMS, Edited by The American Poetry & Literacy Project. Rich treasury of verse from the 19th and 20th centuries includes works by Edgar Allan Poe, Robert Frost, Walt Whitman, Langston Hughes, Emily Dickinson, T. S. Eliot, other notables. 96pp. 5³⁄₁₆ x 8¼. 0-486-40158-8

101 GREAT SAMURAI PRINTS, Utagawa Kuniyoshi. Kuniyoshi was a master of the warrior woodblock print — and these 18th-century illustrations represent the pinnacle of his craft. Full-color portraits of renowned Japanese samurais pulse with movement, passion, and remarkably fine detail. 112pp. 8⅜ x 11. 0-486-46523-3

ABC OF BALLET, Janet Grosser. Clearly worded, abundantly illustrated little guide defines basic ballet-related terms: arabesque, battement, pas de chat, relevé, sissonne, many others. Pronunciation guide included. Excellent primer. 48pp. 4³⁄₁₆ x 5¾.

0-486-40871-X

ACCESSORIES OF DRESS: An Illustrated Encyclopedia, Katherine Lester and Bess Viola Oerke. Illustrations of hats, veils, wigs, cravats, shawls, shoes, gloves, and other accessories enhance an engaging commentary that reveals the humor and charm of the many-sided story of accessorized apparel. 644 figures and 59 plates. 608pp. 6⅛ x 9¼.

0-486-43378-1

ADVENTURES OF HUCKLEBERRY FINN, Mark Twain. Join Huck and Jim as their boyhood adventures along the Mississippi River lead them into a world of excitement, danger, and self-discovery. Humorous narrative, lyrical descriptions of the Mississippi valley, and memorable characters. 224pp. 5³⁄₁₆ x 8¼. 0-486-28061-6

ALICE STARMORE'S BOOK OF FAIR ISLE KNITTING, Alice Starmore. A noted designer from the region of Scotland's Fair Isle explores the history and techniques of this distinctive, stranded-color knitting style and provides copious illustrated instructions for 14 original knitwear designs. 208pp. 8⅜ x 10⅞. 0-486-47218-3

Browse over 9,000 books at www.doverpublications.com

ALICE'S ADVENTURES IN WONDERLAND, Lewis Carroll. Beloved classic about a little girl lost in a topsy-turvy land and her encounters with the White Rabbit, March Hare, Mad Hatter, Cheshire Cat, and other delightfully improbable characters. 42 illustrations by Sir John Tenniel. 96pp. 5³⁄₁₆ x 8¼. 0-486-27543-4

AMERICA'S LIGHTHOUSES: An Illustrated History, Francis Ross Holland. Profusely illustrated fact-filled survey of American lighthouses since 1716. Over 200 stations — East, Gulf, and West coasts, Great Lakes, Hawaii, Alaska, Puerto Rico, the Virgin Islands, and the Mississippi and St. Lawrence Rivers. 240pp. 8 x 10¾.
0-486-25576-X

AN ENCYCLOPEDIA OF THE VIOLIN, Alberto Bachmann. Translated by Frederick H. Martens. Introduction by Eugene Ysaye. First published in 1925, this renowned reference remains unsurpassed as a source of essential information, from construction and evolution to repertoire and technique. Includes a glossary and 73 illustrations. 496pp. 6⅛ x 9¼. 0-486-46618-3

ANIMALS: 1,419 Copyright-Free Illustrations of Mammals, Birds, Fish, Insects, etc., Selected by Jim Harter. Selected for its visual impact and ease of use, this outstanding collection of wood engravings presents over 1,000 species of animals in extremely lifelike poses. Includes mammals, birds, reptiles, amphibians, fish, insects, and other invertebrates. 284pp. 9 x 12. 0-486-23766-4

THE ANNALS, Tacitus. Translated by Alfred John Church and William Jackson Brodribb. This vital chronicle of Imperial Rome, written by the era's great historian, spans A.D. 14-68 and paints incisive psychological portraits of major figures, from Tiberius to Nero. 416pp. 5³⁄₁₆ x 8¼. 0-486-45236-0

ANTIGONE, Sophocles. Filled with passionate speeches and sensitive probing of moral and philosophical issues, this powerful and often-performed Greek drama reveals the grim fate that befalls the children of Oedipus. Footnotes. 64pp. 5³⁄₁₆ x 8 ¼. 0-486-27804-2

ART DECO DECORATIVE PATTERNS IN FULL COLOR, Christian Stoll. Reprinted from a rare 1910 portfolio, 160 sensuous and exotic images depict a breathtaking array of florals, geometrics, and abstracts — all elegant in their stark simplicity. 64pp. 8⅜ x 11. 0-486-44862-2

THE ARTHUR RACKHAM TREASURY: 86 Full-Color Illustrations, Arthur Rackham. Selected and Edited by Jeff A. Menges. A stunning treasury of 86 full-page plates span the famed English artist's career, from *Rip Van Winkle* (1905) to masterworks such as *Undine, A Midsummer Night's Dream,* and *Wind in the Willows* (1939). 96pp. 8⅜ x 11.
0-486-44685-9

THE AUTHENTIC GILBERT & SULLIVAN SONGBOOK, W. S. Gilbert and A. S. Sullivan. The most comprehensive collection available, this songbook includes selections from every one of Gilbert and Sullivan's light operas. Ninety-two numbers are presented uncut and unedited, and in their original keys. 410pp. 9 x 12.
0-486-23482-7

THE AWAKENING, Kate Chopin. First published in 1899, this controversial novel of a New Orleans wife's search for love outside a stifling marriage shocked readers. Today, it remains a first-rate narrative with superb characterization. New introductory Note. 128pp. 5³⁄₁₆ x 8¼. 0-486-27786-0

BASIC DRAWING, Louis Priscilla. Beginning with perspective, this commonsense manual progresses to the figure in movement, light and shade, anatomy, drapery, composition, trees and landscape, and outdoor sketching. Black-and-white illustrations throughout. 128pp. 8⅜ x 11. 0-486-45815-6

Browse over 9,000 books at www.doverpublications.com

THE BATTLES THAT CHANGED HISTORY, Fletcher Pratt. Historian profiles 16 crucial conflicts, ancient to modern, that changed the course of Western civilization. Gripping accounts of battles led by Alexander the Great, Joan of Arc, Ulysses S. Grant, other commanders. 27 maps. 352pp. 5⅜ x 8½.　　　　0-486-41129-X

BEETHOVEN'S LETTERS, Ludwig van Beethoven. Edited by Dr. A. C. Kalischer. Features 457 letters to fellow musicians, friends, greats, patrons, and literary men. Reveals musical thoughts, quirks of personality, insights, and daily events. Includes 15 plates. 410pp. 5⅜ x 8½.　　　　0-486-22769-3

BERNICE BOBS HER HAIR AND OTHER STORIES, F. Scott Fitzgerald. This brilliant anthology includes 6 of Fitzgerald's most popular stories: "The Diamond as Big as the Ritz," the title tale, "The Offshore Pirate," "The Ice Palace," "The Jelly Bean," and "May Day." 176pp. 5⅜ x 8½.　　　　0-486-47049-0

BESLER'S BOOK OF FLOWERS AND PLANTS: 73 Full-Color Plates from Hortus Eystettensis, 1613, Basilius Besler. Here is a selection of magnificent plates from the *Hortus Eystettensis,* which vividly illustrated and identified the plants, flowers, and trees that thrived in the legendary German garden at Eichstätt. 80pp. 8⅜ x 11.
　　　　0-486-46005-3

THE BOOK OF KELLS, Edited by Blanche Cirker. Painstakingly reproduced from a rare facsimile edition, this volume contains full-page decorations, portraits, illustrations, plus a sampling of textual leaves with exquisite calligraphy and ornamentation. 32 full-color illustrations. 32pp. 9⅜ x 12¼.　　　　0-486-24345-1

THE BOOK OF THE CROSSBOW: With an Additional Section on Catapults and Other Siege Engines, Ralph Payne-Gallwey. Fascinating study traces history and use of crossbow as military and sporting weapon, from Middle Ages to modern times. Also covers related weapons: balistas, catapults, Turkish bows, more. Over 240 illustrations. 400pp. 7¼ x 10⅛.　　　　0-486-28720-3

THE BUNGALOW BOOK: Floor Plans and Photos of 112 Houses, 1910, Henry L. Wilson. Here are 112 of the most popular and economic blueprints of the early 20th century — plus an illustration or photograph of each completed house. A wonderful time capsule that still offers a wealth of valuable insights. 160pp. 8⅜ x 11.
　　　　0-486-45104-6

THE CALL OF THE WILD, Jack London. A classic novel of adventure, drawn from London's own experiences as a Klondike adventurer, relating the story of a heroic dog caught in the brutal life of the Alaska Gold Rush. Note. 64pp. 5³⁄₁₆ x 8¼.
　　　　0-486-26472-6

CANDIDE, Voltaire. Edited by Francois-Marie Arouet. One of the world's great satires since its first publication in 1759. Witty, caustic skewering of romance, science, philosophy, religion, government — nearly all human ideals and institutions. 112pp. 5³⁄₁₆ x 8¼.　　　　0-486-26689-3

CELEBRATED IN THEIR TIME: Photographic Portraits from the George Grantham Bain Collection, Edited by Amy Pastan. With an Introduction by Michael Carlebach. Remarkable portrait gallery features 112 rare images of Albert Einstein, Charlie Chaplin, the Wright Brothers, Henry Ford, and other luminaries from the worlds of politics, art, entertainment, and industry. 128pp. 8⅜ x 11.　　　　0-486-46754-6

CHARIOTS FOR APOLLO: The NASA History of Manned Lunar Spacecraft to 1969, Courtney G. Brooks, James M. Grimwood, and Loyd S. Swenson, Jr. This illustrated history by a trio of experts is the definitive reference on the Apollo spacecraft and lunar modules. It traces the vehicles' design, development, and operation in space. More than 100 photographs and illustrations. 576pp. 6¾ x 9¼. 0-486-46756-2

Browse over 9,000 books at www.doverpublications.com

A CHRISTMAS CAROL, Charles Dickens. This engrossing tale relates Ebenezer Scrooge's ghostly journeys through Christmases past, present, and future and his ultimate transformation from a harsh and grasping old miser to a charitable and compassionate human being. 80pp. 5³⁄₁₆ x 8¼. 0-486-26865-9

COMMON SENSE, Thomas Paine. First published in January of 1776, this highly influential landmark document clearly and persuasively argued for American separation from Great Britain and paved the way for the Declaration of Independence. 64pp. 5³⁄₁₆ x 8¼. 0-486-29602-4

THE COMPLETE SHORT STORIES OF OSCAR WILDE, Oscar Wilde. Complete texts of "The Happy Prince and Other Tales," "A House of Pomegranates," "Lord Arthur Savile's Crime and Other Stories," "Poems in Prose," and "The Portrait of Mr. W. H." 208pp. 5³⁄₁₆ x 8¼. 0-486-45216-6

COMPLETE SONNETS, William Shakespeare. Over 150 exquisite poems deal with love, friendship, the tyranny of time, beauty's evanescence, death, and other themes in language of remarkable power, precision, and beauty. Glossary of archaic terms. 80pp. 5³⁄₁₆ x 8¼. 0-486-26686-9

THE COUNT OF MONTE CRISTO: Abridged Edition, Alexandre Dumas. Falsely accused of treason, Edmond Dantès is imprisoned in the bleak Chateau d'If. After a hair-raising escape, he launches an elaborate plot to extract a bitter revenge against those who betrayed him. 448pp. 5³⁄₁₆ x 8¼. 0-486-45643-9

CRAFTSMAN BUNGALOWS: Designs from the Pacific Northwest, Yoho & Merritt. This reprint of a rare catalog, showcasing the charming simplicity and cozy style of Craftsman bungalows, is filled with photos of completed homes, plus floor plans and estimated costs. An indispensable resource for architects, historians, and illustrators. 112pp. 10 x 7. 0-486-46875-5

CRAFTSMAN BUNGALOWS: 59 Homes from "The Craftsman," Edited by Gustav Stickley. Best and most attractive designs from Arts and Crafts Movement publication — 1903–1916 — includes sketches, photographs of homes, floor plans, descriptive text. 128pp. 8¼ x 11. 0-486-25829-7

CRIME AND PUNISHMENT, Fyodor Dostoyevsky. Translated by Constance Garnett. Supreme masterpiece tells the story of Raskolnikov, a student tormented by his own thoughts after he murders an old woman. Overwhelmed by guilt and terror, he confesses and goes to prison. 480pp. 5³⁄₁₆ x 8¼. 0-486-41587-2

THE DECLARATION OF INDEPENDENCE AND OTHER GREAT DOCUMENTS OF AMERICAN HISTORY: 1775-1865, Edited by John Grafton. Thirteen compelling and influential documents: Henry's "Give Me Liberty or Give Me Death," Declaration of Independence, The Constitution, Washington's First Inaugural Address, The Monroe Doctrine, The Emancipation Proclamation, Gettysburg Address, more. 64pp. 5³⁄₁₆ x 8¼. 0-486-41124-9

THE DESERT AND THE SOWN: Travels in Palestine and Syria, Gertrude Bell. "The female Lawrence of Arabia," Gertrude Bell wrote captivating, perceptive accounts of her travels in the Middle East. This intriguing narrative, accompanied by 160 photos, traces her 1905 sojourn in Lebanon, Syria, and Palestine. 368pp. 5⅜ x 8½.
0-486-46876-3

A DOLL'S HOUSE, Henrik Ibsen. Ibsen's best-known play displays his genius for realistic prose drama. An expression of women's rights, the play climaxes when the central character, Nora, rejects a smothering marriage and life in "a doll's house." 80pp. 5³⁄₁₆ x 8¼. 0-486-27062-9

DOOMED SHIPS: Great Ocean Liner Disasters, William H. Miller, Jr. Nearly 200 photographs, many from private collections, highlight tales of some of the vessels whose pleasure cruises ended in catastrophe: the *Morro Castle, Normandie, Andrea Doria, Europa,* and many others. 128pp. 8⅛ x 11¾. 0-486-45366-9

THE DORÉ BIBLE ILLUSTRATIONS, Gustave Doré. Detailed plates from the Bible: the Creation scenes, Adam and Eve, horrifying visions of the Flood, the battle sequences with their monumental crowds, depictions of the life of Jesus, 241 plates in all. 241pp. 9 x 12. 0-486-23004-X

DRAWING DRAPERY FROM HEAD TO TOE, Cliff Young. Expert guidance on how to draw shirts, pants, skirts, gloves, hats, and coats on the human figure, including folds in relation to the body, pull and crush, action folds, creases, more. Over 200 drawings. 48pp. 8¼ x 11. 0-486-45591-2

DUBLINERS, James Joyce. A fine and accessible introduction to the work of one of the 20th century's most influential writers, this collection features 15 tales, including a masterpiece of the short-story genre, "The Dead." 160pp. 5³⁄₁₆ x 8¼.
0-486-26870-5

EASY-TO-MAKE POP-UPS, Joan Irvine. Illustrated by Barbara Reid. Dozens of wonderful ideas for three-dimensional paper fun — from holiday greeting cards with moving parts to a pop-up menagerie. Easy-to-follow, illustrated instructions for more than 30 projects. 299 black-and-white illustrations. 96pp. 8⅜ x 11.
0-486-44622-0

EASY-TO-MAKE STORYBOOK DOLLS: A "Novel" Approach to Cloth Dollmaking, Sherralyn St. Clair. Favorite fictional characters come alive in this unique beginner's dollmaking guide. Includes patterns for Pollyanna, Dorothy from *The Wonderful Wizard of Oz,* Mary of *The Secret Garden,* plus easy-to-follow instructions, 263 black-and-white illustrations, and an 8-page color insert. 112pp. 8¼ x 11. 0-486-47360-0

EINSTEIN'S ESSAYS IN SCIENCE, Albert Einstein. Speeches and essays in accessible, everyday language profile influential physicists such as Niels Bohr and Isaac Newton. They also explore areas of physics to which the author made major contributions. 128pp. 5 x 8. 0-486-47011-3

EL DORADO: Further Adventures of the Scarlet Pimpernel, Baroness Orczy. A popular sequel to *The Scarlet Pimpernel,* this suspenseful story recounts the Pimpernel's attempts to rescue the Dauphin from imprisonment during the French Revolution. An irresistible blend of intrigue, period detail, and vibrant characterizations. 352pp. 5³⁄₁₆ x 8¼. 0-486-44026-5

ELEGANT SMALL HOMES OF THE TWENTIES: 99 Designs from a Competition, Chicago Tribune. Nearly 100 designs for five- and six-room houses feature New England and Southern colonials, Normandy cottages, stately Italianate dwellings, and other fascinating snapshots of American domestic architecture of the 1920s. 112pp. 9 x 12. 0-486-46910-7

THE ELEMENTS OF STYLE: The Original Edition, William Strunk, Jr. This is the book that generations of writers have relied upon for timeless advice on grammar, diction, syntax, and other essentials. In concise terms, it identifies the principal requirements of proper style and common errors. 64pp. 5⅜ x 8½. 0-486-44798-7

THE ELUSIVE PIMPERNEL, Baroness Orczy. Robespierre's revolutionaries find their wicked schemes thwarted by the heroic Pimpernel — Sir Percival Blakeney. In this thrilling sequel, Chauvelin devises a plot to eliminate the Pimpernel and his wife. 272pp. 5³⁄₁₆ x 8¼. 0-486-45464-9

CATALOG OF DOVER BOOKS

AN ENCYCLOPEDIA OF BATTLES: Accounts of Over 1,560 Battles from 1479 B.C. to the Present, David Eggenberger. Essential details of every major battle in recorded history from the first battle of Megiddo in 1479 B.C. to Grenada in 1984. List of battle maps. 99 illustrations. 544pp. 6½ x 9¼. 0-486-24913-1

ENCYCLOPEDIA OF EMBROIDERY STITCHES, INCLUDING CREWEL, Marion Nichols. Precise explanations and instructions, clearly illustrated, on how to work chain, back, cross, knotted, woven stitches, and many more — 178 in all, including Cable Outline, Whipped Satin, and Eyelet Buttonhole. Over 1400 illustrations. 219pp. 8⅜ x 11¼. 0-486-22929-7

ENTER JEEVES: 15 Early Stories, P. G. Wodehouse. Splendid collection contains first 8 stories featuring Bertie Wooster, the deliciously dim aristocrat and Jeeves, his brainy, imperturbable manservant. Also, the complete Reggie Pepper (Bertie's prototype) series. 288pp. 5⅜ x 8½. 0-486-29717-9

ERIC SLOANE'S AMERICA: Paintings in Oil, Michael Wigley. With a Foreword by Mimi Sloane. Eric Sloane's evocative oils of America's landscape and material culture shimmer with immense historical and nostalgic appeal. This original hardcover collection gathers nearly a hundred of his finest paintings, with subjects ranging from New England to the American Southwest. 128pp. 10⅝ x 9.
0-486-46525-X

ETHAN FROME, Edith Wharton. Classic story of wasted lives, set against a bleak New England background. Superbly delineated characters in a hauntingly grim tale of thwarted love. Considered by many to be Wharton's masterpiece. 96pp. 5³⁄₁₆ x 8 ¼.
0-486-26690-7

THE EVERLASTING MAN, G. K. Chesterton. Chesterton's view of Christianity — as a blend of philosophy and mythology, satisfying intellect and spirit — applies to his brilliant book, which appeals to readers' heads as well as their hearts. 288pp. 5⅜ x 8½.
0-486-46036-3

THE FIELD AND FOREST HANDY BOOK, Daniel Beard. Written by a co-founder of the Boy Scouts, this appealing guide offers illustrated instructions for building kites, birdhouses, boats, igloos, and other fun projects, plus numerous helpful tips for campers. 448pp. 5³⁄₁₆ x 8¼. 0-486-46191-2

FINDING YOUR WAY WITHOUT MAP OR COMPASS, Harold Gatty. Useful, instructive manual shows would-be explorers, hikers, bikers, scouts, sailors, and survivalists how to find their way outdoors by observing animals, weather patterns, shifting sands, and other elements of nature. 288pp. 5⅜ x 8½. 0-486-40613-X

FIRST FRENCH READER: A Beginner's Dual-Language Book, Edited and Translated by Stanley Appelbaum. This anthology introduces 50 legendary writers — Voltaire, Balzac, Baudelaire, Proust, more — through passages from *The Red and the Black, Les Misérables, Madame Bovary,* and other classics. Original French text plus English translation on facing pages. 240pp. 5⅜ x 8½. 0-486-46178-5

FIRST GERMAN READER: A Beginner's Dual-Language Book, Edited by Harry Steinhauer. Specially chosen for their power to evoke German life and culture, these short, simple readings include poems, stories, essays, and anecdotes by Goethe, Hesse, Heine, Schiller, and others. 224pp. 5⅜ x 8½. 0-486-46179-3

FIRST SPANISH READER: A Beginner's Dual-Language Book, Angel Flores. Delightful stories, other material based on works of Don Juan Manuel, Luis Taboada, Ricardo Palma, other noted writers. Complete faithful English translations on facing pages. Exercises. 176pp. 5⅜ x 8½. 0-486-25810-6

Browse over 9,000 books at www.doverpublications.com

FIVE ACRES AND INDEPENDENCE, Maurice G. Kains. Great back-to-the-land classic explains basics of self-sufficient farming. The one book to get. 95 illustrations. 397pp. 5⅜ x 8½. 0-486-20974-1

FLAGG'S SMALL HOUSES: Their Economic Design and Construction, 1922, Ernest Flagg. Although most famous for his skyscrapers, Flagg was also a proponent of the well-designed single-family dwelling. His classic treatise features innovations that save space, materials, and cost. 526 illustrations. 160pp. 9⅜ x 12¼.
0-486-45197-6

FLATLAND: A Romance of Many Dimensions, Edwin A. Abbott. Classic of science (and mathematical) fiction — charmingly illustrated by the author — describes the adventures of A. Square, a resident of Flatland, in Spaceland (three dimensions), Lineland (one dimension), and Pointland (no dimensions). 96pp. 5 3/16 x 8¼.
0-486-27263-X

FRANKENSTEIN, Mary Shelley. The story of Victor Frankenstein's monstrous creation and the havoc it caused has enthralled generations of readers and inspired countless writers of horror and suspense. With the author's own 1831 introduction. 176pp. 5 3/16 x 8¼. 0-486-28211-2

THE GARGOYLE BOOK: 572 Examples from Gothic Architecture, Lester Burbank Bridaham. Dispelling the conventional wisdom that French Gothic architectural flourishes were born of despair or gloom, Bridaham reveals the whimsical nature of these creations and the ingenious artisans who made them. 572 illustrations. 224pp. 8⅜ x 11. 0-486-44754-5

THE GIFT OF THE MAGI AND OTHER SHORT STORIES, O. Henry. Sixteen captivating stories by one of America's most popular storytellers. Included are such classics as "The Gift of the Magi," "The Last Leaf," and "The Ransom of Red Chief." Publisher's Note. 96pp. 5 3/16 x 8¼. 0-486-27061-0

THE GOETHE TREASURY: Selected Prose and Poetry, Johann Wolfgang von Goethe. Edited, Selected, and with an Introduction by Thomas Mann. In addition to his lyric poetry, Goethe wrote travel sketches, autobiographical studies, essays, letters, and proverbs in rhyme and prose. This collection presents outstanding examples from each genre. 368pp. 5⅜ x 8½. 0-486-44780-4

GREAT EXPECTATIONS, Charles Dickens. Orphaned Pip is apprenticed to the dirty work of the forge but dreams of becoming a gentleman — and one day finds himself in possession of "great expectations." Dickens' finest novel. 400pp. 5 3/16 x 8¼.
0-486-41586-4

GREAT WRITERS ON THE ART OF FICTION: From Mark Twain to Joyce Carol Oates, Edited by James Daley. An indispensable source of advice and inspiration, this anthology features essays by Henry James, Kate Chopin, Willa Cather, Sinclair Lewis, Jack London, Raymond Chandler, Raymond Carver, Eudora Welty, and Kurt Vonnegut, Jr. 192pp. 5⅜ x 8½. 0-486-45128-3

HAMLET, William Shakespeare. The quintessential Shakespearean tragedy, whose highly charged confrontations and anguished soliloquies probe depths of human feeling rarely sounded in any art. Reprinted from an authoritative British edition complete with illuminating footnotes. 128pp. 5 3/16 x 8¼. 0-486-27278-8

THE HAUNTED HOUSE, Charles Dickens. A Yuletide gathering in an eerie country retreat provides the backdrop for Dickens and his friends — including Elizabeth Gaskell and Wilkie Collins — who take turns spinning supernatural yarns. 144pp. 5⅜ x 8½. 0-486-46309-5

HEART OF DARKNESS, Joseph Conrad. Dark allegory of a journey up the Congo River and the narrator's encounter with the mysterious Mr. Kurtz. Masterly blend of adventure, character study, psychological penetration. For many, Conrad's finest, most enigmatic story. 80pp. 5¾₆ x 8¼. 0-486-26464-5

HENSON AT THE NORTH POLE, Matthew A. Henson. This thrilling memoir by the heroic African-American who was Peary's companion through two decades of Arctic exploration recounts a tale of danger, courage, and determination. "Fascinating and exciting." — *Commonweal*. 128pp. 5⅜ x 8½. 0-486-45472-X

HISTORIC COSTUMES AND HOW TO MAKE THEM, Mary Fernald and E. Shenton. Practical, informative guidebook shows how to create everything from short tunics worn by Saxon men in the fifth century to a lady's bustle dress of the late 1800s. 81 illustrations. 176pp. 5⅜ x 8½. 0-486-44906-8

THE HOUND OF THE BASKERVILLES, Arthur Conan Doyle. A deadly curse in the form of a legendary ferocious beast continues to claim its victims from the Baskerville family until Holmes and Watson intervene. Often called the best detective story ever written. 128pp. 5¾₆ x 8¼. 0-486-28214-7

THE HOUSE BEHIND THE CEDARS, Charles W. Chesnutt. Originally published in 1900, this groundbreaking novel by a distinguished African-American author recounts the drama of a brother and sister who "pass for white" during the dangerous days of Reconstruction. 208pp. 5⅜ x 8½. 0-486-46144-0

THE HUMAN FIGURE IN MOTION, Eadweard Muybridge. The 4,789 photographs in this definitive selection show the human figure — models almost all undraped — engaged in over 160 different types of action: running, climbing stairs, etc. 390pp. 7⅞ x 10⅝. 0-486-20204-6

THE IMPORTANCE OF BEING EARNEST, Oscar Wilde. Wilde's witty and buoyant comedy of manners, filled with some of literature's most famous epigrams, reprinted from an authoritative British edition. Considered Wilde's most perfect work. 64pp. 5¾₆ x 8¼. 0-486-26478-5

THE INFERNO, Dante Alighieri. Translated and with notes by Henry Wadsworth Longfellow. The first stop on Dante's famous journey from Hell to Purgatory to Paradise, this 14th-century allegorical poem blends vivid and shocking imagery with graceful lyricism. Translated by the beloved 19th-century poet, Henry Wadsworth Longfellow. 256pp. 5¾₆ x 8¼. 0-486-44288-8

JANE EYRE, Charlotte Brontë. Written in 1847, *Jane Eyre* tells the tale of an orphan girl's progress from the custody of cruel relatives to an oppressive boarding school and its culmination in a troubled career as a governess. 448pp. 5¾₆ x 8¼.
0-486-42449-9

JAPANESE WOODBLOCK FLOWER PRINTS, Tanigami Kônan. Extraordinary collection of Japanese woodblock prints by a well-known artist features 120 plates in brilliant color. Realistic images from a rare edition include daffodils, tulips, and other familiar and unusual flowers. 128pp. 11 x 8¼. 0-486-46442-3

JEWELRY MAKING AND DESIGN, Augustus F. Rose and Antonio Cirino. Professional secrets of jewelry making are revealed in a thorough, practical guide. Over 200 illustrations. 306pp. 5⅜ x 8½. 0-486-21750-7

JULIUS CAESAR, William Shakespeare. Great tragedy based on Plutarch's account of the lives of Brutus, Julius Caesar and Mark Antony. Evil plotting, ringing oratory, high tragedy with Shakespeare's incomparable insight, dramatic power. Explanatory footnotes. 96pp. 5¾₆ x 8¼. 0-486-26876-4

THE JUNGLE, Upton Sinclair. 1906 bestseller shockingly reveals intolerable labor practices and working conditions in the Chicago stockyards as it tells the grim story of a Slavic family that emigrates to America full of optimism but soon faces despair. 320pp. 5 3/16 x 8 1/4. 0-486-41923-1

THE KINGDOM OF GOD IS WITHIN YOU, Leo Tolstoy. The soul-searching book that inspired Gandhi to embrace the concept of passive resistance, Tolstoy's 1894 polemic clearly outlines a radical, well-reasoned revision of traditional Christian thinking. 352pp. 5 3/16 x 8 1/4. 0-486-45138-0

THE LADY OR THE TIGER?: and Other Logic Puzzles, Raymond M. Smullyan. Created by a renowned puzzle master, these whimsically themed challenges involve paradoxes about probability, time, and change; metapuzzles; and self-referentiality. Nineteen chapters advance in difficulty from relatively simple to highly complex. 1982 edition. 240pp. 5 3/8 x 8 1/2. 0-486-47027-X

LEAVES OF GRASS: The Original 1855 Edition, Walt Whitman. Whitman's immortal collection includes some of the greatest poems of modern times, including his masterpiece, "Song of Myself." Shattering standard conventions, it stands as an unabashed celebration of body and nature. 128pp. 5 3/16 x 8 1/4. 0-486-45676-5

LES MISÉRABLES, Victor Hugo. Translated by Charles E. Wilbour. Abridged by James K. Robinson. A convict's heroic struggle for justice and redemption plays out against a fiery backdrop of the Napoleonic wars. This edition features the excellent original translation and a sensitive abridgment. 304pp. 6 1/8 x 9 1/4.
0-486-45789-3

LILITH: A Romance, George MacDonald. In this novel by the father of fantasy literature, a man travels through time to meet Adam and Eve and to explore humanity's fall from grace and ultimate redemption. 240pp. 5 3/8 x 8 1/2.
0-486-46818-6

THE LOST LANGUAGE OF SYMBOLISM, Harold Bayley. This remarkable book reveals the hidden meaning behind familiar images and words, from the origins of Santa Claus to the fleur-de-lys, drawing from mythology, folklore, religious texts, and fairy tales. 1,418 illustrations. 784pp. 5 3/8 x 8 1/2. 0-486-44787-1

MACBETH, William Shakespeare. A Scottish nobleman murders the king in order to succeed to the throne. Tortured by his conscience and fearful of discovery, he becomes tangled in a web of treachery and deceit that ultimately spells his doom. 96pp. 5 3/16 x 8 1/4. 0-486-27802-6

MAKING AUTHENTIC CRAFTSMAN FURNITURE: Instructions and Plans for 62 Projects, Gustav Stickley. Make authentic reproductions of handsome, functional, durable furniture: tables, chairs, wall cabinets, desks, a hall tree, and more. Construction plans with drawings, schematics, dimensions, and lumber specs reprinted from 1900s The Craftsman magazine. 128pp. 8 1/8 x 11. 0-486-25000-8

MATHEMATICS FOR THE NONMATHEMATICIAN, Morris Kline. Erudite and entertaining overview follows development of mathematics from ancient Greeks to present. Topics include logic and mathematics, the fundamental concept, differential calculus, probability theory, much more. Exercises and problems. 641pp. 5 3/8 x 8 1/2. 0-486-24823-2

MEMOIRS OF AN ARABIAN PRINCESS FROM ZANZIBAR, Emily Ruete. This 19th-century autobiography offers a rare inside look at the society surrounding a sultan's palace. A real-life princess in exile recalls her vanished world of harems, slave trading, and court intrigues. 288pp. 5 3/8 x 8 1/2. 0-486-47121-7

Browse over 9,000 books at www.doverpublications.com

THE METAMORPHOSIS AND OTHER STORIES, Franz Kafka. Excellent new English translations of title story (considered by many critics Kafka's most perfect work), plus "The Judgment," "In the Penal Colony," "A Country Doctor," and "A Report to an Academy." Note. 96pp. 5⅜₆ x 8¼. 0-486-29030-1

MICROSCOPIC ART FORMS FROM THE PLANT WORLD, R. Anheisser. From undulating curves to complex geometrics, a world of fascinating images abound in this classic, illustrated survey of microscopic plants. Features 400 detailed illustrations of nature's minute but magnificent handiwork. The accompanying CD-ROM includes all of the images in the book. 128pp. 9 x 9. 0-486-46013-4

A MIDSUMMER NIGHT'S DREAM, William Shakespeare. Among the most popular of Shakespeare's comedies, this enchanting play humorously celebrates the vagaries of love as it focuses upon the intertwined romances of several pairs of lovers. Explanatory footnotes. 80pp. 5⅜₆ x 8¼. 0-486-27067-X

THE MONEY CHANGERS, Upton Sinclair. Originally published in 1908, this cautionary novel from the author of *The Jungle* explores corruption within the American system as a group of power brokers joins forces for personal gain, triggering a crash on Wall Street. 192pp. 5⅜ x 8½. 0-486-46917-4

THE MOST POPULAR HOMES OF THE TWENTIES, William A. Radford. With a New Introduction by Daniel D. Reiff. Based on a rare 1925 catalog, this architectural showcase features floor plans, construction details, and photos of 26 homes, plus articles on entrances, porches, garages, and more. 250 illustrations, 21 color plates. 176pp. 8⅜ x 11. 0-486-47028-8

MY 66 YEARS IN THE BIG LEAGUES, Connie Mack. With a New Introduction by Rich Westcott. A Founding Father of modern baseball, Mack holds the record for most wins — and losses — by a major league manager. Enhanced by 70 photographs, his warmhearted autobiography is populated by many legends of the game. 288pp. 5⅜ x 8½. 0-486-47184-5

NARRATIVE OF THE LIFE OF FREDERICK DOUGLASS, Frederick Douglass. Douglass's graphic depictions of slavery, harrowing escape to freedom, and life as a newspaper editor, eloquent orator, and impassioned abolitionist. 96pp. 5⅜₆ x 8¼.
0-486-28499-9

THE NIGHTLESS CITY: Geisha and Courtesan Life in Old Tokyo, J. E. de Becker. This unsurpassed study from 100 years ago ventured into Tokyo's red-light district to survey geisha and courtesan life and offer meticulous descriptions of training, dress, social hierarchy, and erotic practices. 49 black-and-white illustrations; 2 maps. 496pp. 5⅜ x 8½. 0-486-45563-7

THE ODYSSEY, Homer. Excellent prose translation of ancient epic recounts adventures of the homeward-bound Odysseus. Fantastic cast of gods, giants, cannibals, sirens, other supernatural creatures — true classic of Western literature. 256pp. 5⅜₆ x 8¼.
0-486-40654-7

OEDIPUS REX, Sophocles. Landmark of Western drama concerns the catastrophe that ensues when King Oedipus discovers he has inadvertently killed his father and married his mother. Masterly construction, dramatic irony. Explanatory footnotes. 64pp. 5⅜₆ x 8¼. 0-486-26877-2

ONCE UPON A TIME: The Way America Was, Eric Sloane. Nostalgic text and drawings brim with gentle philosophies and descriptions of how we used to live — self-sufficiently — on the land, in homes, and among the things built by hand. 44 line illustrations. 64pp. 8⅜ x 11. 0-486-44411-2

ONE OF OURS, Willa Cather. The Pulitzer Prize–winning novel about a young Nebraskan looking for something to believe in. Alienated from his parents, rejected by his wife, he finds his destiny on the bloody battlefields of World War I. 352pp. 5³⁄₁₆ x 8¼. 0-486-45599-8

ORIGAMI YOU CAN USE: 27 Practical Projects, Rick Beech. Origami models can be more than decorative, and this unique volume shows how! The 27 practical projects include a CD case, frame, napkin ring, and dish. Easy instructions feature 400 two-color illustrations. 96pp. 8¼ x 11. 0-486-47057-1

OTHELLO, William Shakespeare. Towering tragedy tells the story of a Moorish general who earns the enmity of his ensign Iago when he passes him over for a promotion. Masterly portrait of an archvillain. Explanatory footnotes. 112pp. 5³⁄₁₆ x 8¼.
0-486-29097-2

PARADISE LOST, John Milton. Notes by John A. Himes. First published in 1667, *Paradise Lost* ranks among the greatest of English literature's epic poems. It's a sublime retelling of Adam and Eve's fall from grace and expulsion from Eden. Notes by John A. Himes. 480pp. 5³⁄₁₆ x 8¼. 0-486-44287-X

PASSING, Nella Larsen. Married to a successful physician and prominently ensconced in society, Irene Redfield leads a charmed existence — until a chance encounter with a childhood friend who has been "passing for white." 112pp. 5⅜ x 8½. 0-486-43713-2

PERSPECTIVE DRAWING FOR BEGINNERS, Len A. Doust. Doust carefully explains the roles of lines, boxes, and circles, and shows how visualizing shapes and forms can be used in accurate depictions of perspective. One of the most concise introductions available. 33 illustrations. 64pp. 5⅜ x 8½. 0-486-45149-6

PERSPECTIVE MADE EASY, Ernest R. Norling. Perspective is easy; yet, surprisingly few artists know the simple rules that make it so. Remedy that situation with this simple, step-by-step book, the first devoted entirely to the topic. 256 illustrations. 224pp. 5⅜ x 8½. 0-486-40473-0

THE PICTURE OF DORIAN GRAY, Oscar Wilde. Celebrated novel involves a handsome young Londoner who sinks into a life of depravity. His body retains perfect youth and vigor while his recent portrait reflects the ravages of his crime and sensuality. 176pp. 5³⁄₁₆ x 8¼. 0-486-27807-7

PRIDE AND PREJUDICE, Jane Austen. One of the most universally loved and admired English novels, an effervescent tale of rural romance transformed by Jane Austen's art into a witty, shrewdly observed satire of English country life. 272pp. 5³⁄₁₆ x 8¼.
0-486-28473-5

THE PRINCE, Niccolò Machiavelli. Classic, Renaissance-era guide to acquiring and maintaining political power. Today, nearly 500 years after it was written, this calculating prescription for autocratic rule continues to be much read and studied. 80pp. 5³⁄₁₆ x 8¼. 0-486-27274-5

QUICK SKETCHING, Carl Cheek. A perfect introduction to the technique of "quick sketching." Drawing upon an artist's immediate emotional responses, this is an extremely effective means of capturing the essential form and features of a subject. More than 100 black-and-white illustrations throughout. 48pp. 11 x 8¼.
0-486-46608-6

RANCH LIFE AND THE HUNTING TRAIL, Theodore Roosevelt. Illustrated by Frederic Remington. Beautifully illustrated by Remington, Roosevelt's celebration of the Old West recounts his adventures in the Dakota Badlands of the 1880s, from roundups to Indian encounters to hunting bighorn sheep. 208pp. 6¼ x 9¼. 0-486-47340-6

Browse over 9,000 books at www.doverpublications.com

THE RED BADGE OF COURAGE, Stephen Crane. Amid the nightmarish chaos of a Civil War battle, a young soldier discovers courage, humility, and, perhaps, wisdom. Uncanny re-creation of actual combat. Enduring landmark of American fiction. 112pp. 5³⁄₁₆ x 8¼. 0-486-26465-3

RELATIVITY SIMPLY EXPLAINED, Martin Gardner. One of the subject's clearest, most entertaining introductions offers lucid explanations of special and general theories of relativity, gravity, and spacetime, models of the universe, and more. 100 illustrations. 224pp. 5⅜ x 8½. 0-486-29315-7

REMBRANDT DRAWINGS: 116 Masterpieces in Original Color, Rembrandt van Rijn. This deluxe hardcover edition features drawings from throughout the Dutch master's prolific career. Informative captions accompany these beautifully reproduced landscapes, biblical vignettes, figure studies, animal sketches, and portraits. 128pp. 8⅜ x 11. 0-486-46149-1

THE ROAD NOT TAKEN AND OTHER POEMS, Robert Frost. A treasury of Frost's most expressive verse. In addition to the title poem: "An Old Man's Winter Night," "In the Home Stretch," "Meeting and Passing," "Putting in the Seed," many more. All complete and unabridged. 64pp. 5³⁄₁₆ x 8¼. 0-486-27550-7

ROMEO AND JULIET, William Shakespeare. Tragic tale of star-crossed lovers, feuding families and timeless passion contains some of Shakespeare's most beautiful and lyrical love poetry. Complete, unabridged text with explanatory footnotes. 96pp. 5³⁄₁₆ x 8¼. 0-486-27557-4

SANDITON AND THE WATSONS: Austen's Unfinished Novels, Jane Austen. Two tantalizing incomplete stories revisit Austen's customary milieu of courtship and venture into new territory, amid guests at a seaside resort. Both are worth reading for pleasure and study. 112pp. 5⅜ x 8½. 0-486-45793-1

THE SCARLET LETTER, Nathaniel Hawthorne. With stark power and emotional depth, Hawthorne's masterpiece explores sin, guilt, and redemption in a story of adultery in the early days of the Massachusetts Colony. 192pp. 5³⁄₁₆ x 8¼. 0-486-28048-9

THE SEASONS OF AMERICA PAST, Eric Sloane. Seventy-five illustrations depict cider mills and presses, sleds, pumps, stump-pulling equipment, plows, and other elements of America's rural heritage. A section of old recipes and household hints adds additional color. 160pp. 8⅜ x 11. 0-486-44220-9

SELECTED CANTERBURY TALES, Geoffrey Chaucer. Delightful collection includes the General Prologue plus three of the most popular tales: "The Knight's Tale," "The Miller's Prologue and Tale," and "The Wife of Bath's Prologue and Tale." In modern English. 144pp. 5³⁄₁₆ x 8¼. 0-486-28241-4

SELECTED POEMS, Emily Dickinson. Over 100 best-known, best-loved poems by one of America's foremost poets, reprinted from authoritative early editions. No comparable edition at this price. Index of first lines. 64pp. 5³⁄₁₆ x 8¼. 0-486-26466-1

SIDDHARTHA, Hermann Hesse. Classic novel that has inspired generations of seekers. Blending Eastern mysticism and psychoanalysis, Hesse presents a strikingly original view of man and culture and the arduous process of self-discovery, reconciliation, harmony, and peace. 112pp. 5³⁄₁₆ x 8¼. 0-486-40653-9

SKETCHING OUTDOORS, Leonard Richmond. This guide offers beginners step-by-step demonstrations of how to depict clouds, trees, buildings, and other outdoor sights. Explanations of a variety of techniques include shading and constructional drawing. 48pp. 11 x 8¼. 0-486-46922-0

SMALL HOUSES OF THE FORTIES: With Illustrations and Floor Plans, Harold E. Group. 56 floor plans and elevations of houses that originally cost less than $15,000 to build. Recommended by financial institutions of the era, they range from Colonials to Cape Cods. 144pp. 8⅜ x 11. 0-486-45598-X

SOME CHINESE GHOSTS, Lafcadio Hearn. Rooted in ancient Chinese legends, these richly atmospheric supernatural tales are recounted by an expert in Oriental lore. Their originality, power, and literary charm will captivate readers of all ages. 96pp. 5⅜ x 8½. 0-486-46306-0

SONGS FOR THE OPEN ROAD: Poems of Travel and Adventure, Edited by The American Poetry & Literacy Project. More than 80 poems by 50 American and British masters celebrate real and metaphorical journeys. Poems by Whitman, Byron, Millay, Sandburg, Langston Hughes, Emily Dickinson, Robert Frost, Shelley, Tennyson, Yeats, many others. Note. 80pp. 5³⁄₁₆ x 8¼. 0-486-40646-6

SPOON RIVER ANTHOLOGY, Edgar Lee Masters. An American poetry classic, in which former citizens of a mythical midwestern town speak touchingly from the grave of the thwarted hopes and dreams of their lives. 144pp. 5³⁄₁₆ x 8¼.
0-486-27275-3

STAR LORE: Myths, Legends, and Facts, William Tyler Olcott. Captivating retellings of the origins and histories of ancient star groups include Pegasus, Ursa Major, Pleiades, signs of the zodiac, and other constellations. "Classic." — *Sky & Telescope.* 58 illustrations. 544pp. 5⅜ x 8½. 0-486-43581-4

THE STRANGE CASE OF DR. JEKYLL AND MR. HYDE, Robert Louis Stevenson. This intriguing novel, both fantasy thriller and moral allegory, depicts the struggle of two opposing personalities — one essentially good, the other evil — for the soul of one man. 64pp. 5³⁄₁₆ x 8¼. 0-486-26688-5

SURVIVAL HANDBOOK: The Official U.S. Army Guide, Department of the Army. This special edition of the Army field manual is geared toward civilians. An essential companion for campers and all lovers of the outdoors, it constitutes the most authoritative wilderness guide. 288pp. 5³⁄₁₆ x 8¼. 0-486-46184-X

A TALE OF TWO CITIES, Charles Dickens. Against the backdrop of the French Revolution, Dickens unfolds his masterpiece of drama, adventure, and romance about a man falsely accused of treason. Excitement and derring-do in the shadow of the guillotine. 304pp. 5³⁄₁₆ x 8¼. 0-486-40651-2

TEN PLAYS, Anton Chekhov. *The Sea Gull, Uncle Vanya, The Three Sisters, The Cherry Orchard,* and *Ivanov,* plus 5 one-act comedies: *The Anniversary, An Unwilling Martyr, The Wedding, The Bear,* and *The Proposal.* 336pp. 5³⁄₁₆ x 8¼. 0-486-46560-8

THE FLYING INN, G. K. Chesterton. Hilarious romp in which pub owner Humphrey Hump and friend take to the road in a donkey cart filled with rum and cheese, inveighing against Prohibition and other "oppressive forms of modernity." 320pp. 5⅜ x 8½. 0-486-41910-X

THIRTY YEARS THAT SHOOK PHYSICS: The Story of Quantum Theory, George Gamow. Lucid, accessible introduction to the influential theory of energy and matter features careful explanations of Dirac's anti-particles, Bohr's model of the atom, and much more. Numerous drawings. 1966 edition. 240pp. 5⅜ x 8½. 0-486-24895-X

TREASURE ISLAND, Robert Louis Stevenson. Classic adventure story of a perilous sea journey, a mutiny led by the infamous Long John Silver, and a lethal scramble for buried treasure — seen through the eyes of cabin boy Jim Hawkins. 160pp. 5³⁄₁₆ x 8¼.
0-486-27559-0

Browse over 9,000 books at www.doverpublications.com

THE TRIAL, Franz Kafka. Translated by David Wyllie. From its gripping first sentence onward, this novel exemplifies the term "Kafkaesque." Its darkly humorous narrative recounts a bank clerk's entrapment in a bureaucratic maze, based on an undisclosed charge. 176pp. 5³⁄₁₆ x 8¼. 0-486-47061-X

THE TURN OF THE SCREW, Henry James. Gripping ghost story by great novelist depicts the sinister transformation of 2 innocent children into flagrant liars and hypocrites. An elegantly told tale of unspoken horror and psychological terror. 96pp. 5³⁄₁₆ x 8¼. 0-486-26684-2

UP FROM SLAVERY, Booker T. Washington. Washington (1856-1915) rose to become the most influential spokesman for African-Americans of his day. In this eloquently written book, he describes events in a remarkable life that began in bondage and culminated in worldwide recognition. 160pp. 5³⁄₁₆ x 8¼. 0-486-28738-6

VICTORIAN HOUSE DESIGNS IN AUTHENTIC FULL COLOR: 75 Plates from the "Scientific American – Architects and Builders Edition," 1885-1894, Edited by Blanche Cirker. Exquisitely detailed, exceptionally handsome designs for an enormous variety of attractive city dwellings, spacious suburban and country homes, charming "cottages" and other structures — all accompanied by perspective views and floor plans. 80pp. 9¼ x 12¼. 0-486-29438-2

VILLETTE, Charlotte Brontë. Acclaimed by Virginia Woolf as "Brontë's finest novel," this moving psychological study features a remarkably modern heroine who abandons her native England for a new life as a schoolteacher in Belgium. 480pp. 5³⁄₁₆ x 8¼. 0-486-45557-2

THE VOYAGE OUT, Virginia Woolf. A moving depiction of the thrills and confusion of youth, Woolf's acclaimed first novel traces a shipboard journey to South America for a captivating exploration of a woman's growing self-awareness. 288pp. 5³⁄₁₆ x 8¼. 0-486-45005-8

WALDEN; OR, LIFE IN THE WOODS, Henry David Thoreau. Accounts of Thoreau's daily life on the shores of Walden Pond outside Concord, Massachusetts, are interwoven with musings on the virtues of self-reliance and individual freedom, on society, government, and other topics. 224pp. 5³⁄₁₆ x 8¼. 0-486-28495-6

WILD PILGRIMAGE: A Novel in Woodcuts, Lynd Ward. Through startling engravings shaded in black and red, Ward wordlessly tells the story of a man trapped in an industrial world, struggling between the grim reality around him and the fantasies his imagination creates. 112pp. 6⅛ x 9¼. 0-486-46583-7

WILLY POGÁNY REDISCOVERED, Willy Pogány. Selected and Edited by Jeff A. Menges. More than 100 color and black-and-white Art Nouveau–style illustrations from fairy tales and adventure stories include scenes from Wagner's "Ring" cycle, *The Rime of the Ancient Mariner, Gulliver's Travels,* and *Faust.* 144pp. 8⅜ x 11.
0-486-47046-6

WOOLLY THOUGHTS: Unlock Your Creative Genius with Modular Knitting, Pat Ashforth and Steve Plummer. Here's the revolutionary way to knit — easy, fun, and foolproof! Beginners and experienced knitters need only master a single stitch to create their own designs with patchwork squares. More than 100 illustrations. 128pp. 6½ x 9¼. 0-486-46084-3

WUTHERING HEIGHTS, Emily Brontë. Somber tale of consuming passions and vengeance — played out amid the lonely English moors — recounts the turbulent and tempestuous love story of Cathy and Heathcliff. Poignant and compelling. 256pp. 5³⁄₁₆ x 8¼. 0-486-29256-8